# 101

## Techniques

# Drawing

# BARRON'S

# 101 Techniques / Drawing

In art, the practice is always a step ahead of the theory, blazing a trail that will later be studied and measured by the theoretical minds. Of all the lessons that can be taught about drawing, the best is the example of an artist in action. This book is essentially a practical one, which teaches with examples: it teaches you to draw by drawing.

**The lessons contained in this book are essentially exercises.** After familiarizing the reader with the appropriate drawing tools, we present no less than 101 practical examples of how to use the most important techniques of artistic drawing. We could have selected fewer techniques, since a pencil, a piece of paper, a little bit of knowledge, and the desire to draw are all you need to have to be able to draw. We also could have included a lot more, since every experienced artist knows that their drawing apprenticeship never really ends, that they are continuously discovering new possibilities, and that the eagerness to explore them is precisely what keeps their creativity functioning. But the 101 techniques that are collected here constitute the most complete repertory of approaches in existence, a combination of subject and stylistic factors with the various techniques of artistic drawing. Thus, each exercise is a meeting point for a group of typical materials, a particular style, and a specific subject. The order of the sections is functional and answers to the necessity of organizing the teaching using a scheme based on the different typical materials of the artist: graphite, chalk, color pencils, pastels, and ink. You are not required to do them in order; you can always choose something else, and move forward or back as you wish.

**Each exercise is a step-by-step sequence** that occupies one or two pages. The difficulty has nothing to do with the length of the lesson, and it is labeled with one or two stars. One star means that the approach is appropriate for beginning artists; two stars are for artists with a little more experience. But beginners should not ignore the exercises with two stars because they can learn as much or more from them as from the simpler exercises. The golden rule for all who wish to learn is to always attempt things that are just a bit beyond your capabilities.

**This book was written by a group of professionals** who together have vast experience in creating and publishing books for learning to draw and paint. Their experience has guided them in creating something that is positively useful for beginners as well as for experienced, and even professional, artists. This work is always clear, direct, and accessible as a learning tool, as well as varied and attractive as a purely esthetic reference. We are certain that you will be able to see and appreciate the value of all of these aspects.

# Contents

level **Beginner**    level **Advanced**

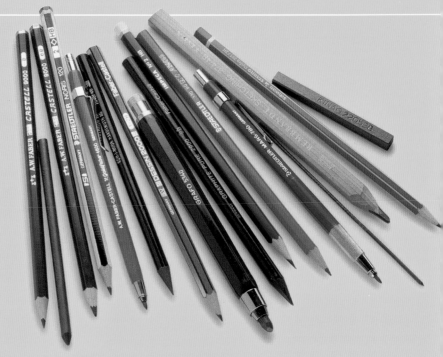

### The Graphite Pencil

To draw, you barely need anything more than a pencil and a piece of paper for tools. Of course, knowing the techniques and constant exploration of creative approaches will provide you with a growing range of methods and specialized tools to practice with, although each of the different media requires a particular technique and its own particular tools.

The generic term pencil, for example, covers a wide variety of versions including, among others, hard pencils, soft pencils, graphite pencils, charcoal pencils, grease pencils, color pencils, and pastel pencils. Graphite pencils typically consist of a lead made of graphite mixed with clay and encased in a cylinder of cedar wood, although you can also buy them as a thick stick of graphite to be used with a holder.

### The Hardness of the Lead

The graphite pencil, also called a lead pencil, offers a great variety of tonal ranges and notable differences in line depending on the hardness of the lead, the quality, and the sharpness of the point. The scale of hardness of these pencils clearly distinguishes between soft and hard pencils. The soft ones are more appropriate for drawing because they allow you to create different gradations, from very light grays to very dark blacks. The hard pencils, on the other hand, are used for linear and technical drawings because of their soft light tones, and because their hardness helps them maintain their sharp point longer, unlike soft pencils.

Graphite is normally available in conventional pencils of varying degrees of hardness, but also can be found as leads of different thickness that can be used alone or inserted in holders.

There is a standard classification that is expressed by a combination of numbers and letters marked on one end of the pencils. On hard pencils, the numbers are followed by the letter H, and the leads are harder as the numbers go higher. On soft pencils, the numbers are followed by the letter B. The softest pencil is the 8B, and the hardest pencil, with the lightest line, is the 9H. The most popular pencils are the HB (a hard pencil that makes a clearly visible line) and the 2B, 4B, and 6B, used to make lines of different intensities.

Graphite pencils are available in a wide range of hardness that include 10 or 12 varieties: from a very hard lead that makes a nearly imperceptible line to a lead that that is very soft and makes a very dark line.

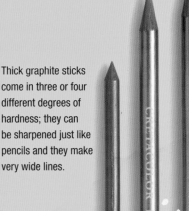

Thick graphite sticks come in three or four different degrees of hardness; they can be sharpened just like pencils and they make very wide lines.

## Charcoal

Charcoal is one of the most ancient materials used by artists, dating back to the origins of visual art. Vegetable charcoal for drawing, or vine charcoal, comes in sticks of different thickness, and can be made from carbonized willow, grapevines, or walnut. They make a very dark gray line, which can easily be blended and erased and must be fixed when the work is finished to keep it from eventually coming off the paper. Vine charcoal can be combined with other media to create interesting effects of volume and light, for example sanguine crayon, on color paper.

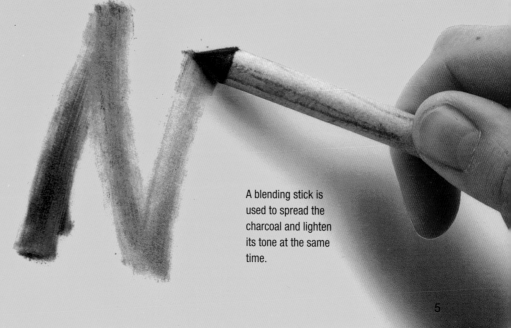

Charcoal pencils are also available in different degrees of hardness and can be used to make very precise lines.

Vine charcoal is a stick that has been carbonized, with a very dark gray color, and that makes a smooth stroke. It is available in several widths.

## Varieties of Charcoal

In addition to the traditional sticks of carbonized wood, there are many other varieties and forms of charcoal. Sticks of artificial compressed charcoal are common, as are charcoal pencils, and sticks of charcoal agglutinated with clay in diameters up to 3/16 inch (5 mm) for use with holders. These varieties are very stable and generally are of high quality. They are very useful for their dark line, which is darker even than vine charcoal and also more permanent.

A blending stick is used to spread the charcoal and lighten its tone at the same time.

## Pastels

Pastels are sticks of agglutinated color that make lines that range from wide to narrow depending on their hardness. They are commonly available in two varieties: fat sticks that make wide lines and are known as soft pastels, or simply pastels; and thin sticks that make a more precise line that are called hard pastels, or chalk.

In pencil form, the colors are also made from agglutinated pigment, but with much less pigment and with a harder consistency, which allows you to draw finer lines.

## Soft Pastels

Soft pastels are manufactured with just enough agglutinate for the sticks to maintain their consistency and so they can deposit the greatest amount of pigment while drawing. Their lines are wide, dense, and difficult to control; in fact, pastel drawings are more about applications of color than strokes or combinations of lines.

Strokes of soft pastel can be easily blended by rubbing them with your fingertips or a cotton rag, and they can be removed with a rubber eraser, although with more difficulty than charcoal lines.

All pastel drawings must be protected with a spray fixative after they are finished to stabilize the pigment on the paper and keep it from falling off.

## Hard Pastels and Chalk

Hard pastels are smaller than soft pastels, and they contain a greater amount of agglutinate. This makes their lines more stable, finer, and with a consistent width, but they do not deposit as much color as the soft pastels. They are used more for drawing in color than actually coloring (or painting), and because of their hardness, you do not have to use a spray fixative.

Compared with soft pastels, hard pastel sticks are of lower quality but make thinner, more precise lines.

## Sanguine Crayon

Sanguine crayon is an oxide red pastel, very commonly used by artists because of the warmth of its tone, and because it combines well with charcoal. It is usually available as hard pastel sticks and also as pastel pencils.

The combination of sanguine, charcoal, and white chalk on color paper is one of the most elegant and traditional techniques of artistic drawing.

Pastels come in a very wide range of colors and manufacturers offer dozens of different tones of the sticks of agglutinated pigment.

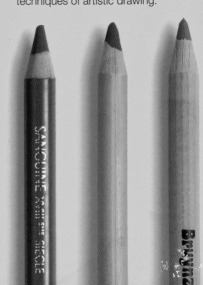

Sanguine is a hard pastel in earth red (red oxide) that is usually available in sticks and pencil form.

## Pastel Pencils

These tools are like normal pencils, but the consistency of the lead is similar to that of hard pastels and chalk. They are not used very much because their point is very fragile and they are difficult to sharpen, but artists commonly use certain colors of this type of pencil, like sanguine, black, and the earth tones in general.

Color pencils are available in very large sets, but the most important manufacturers also sell them individually.

Pastel pencils are smaller versions of the hard pastels. They can be used to complement drawings made with regular pastels for drawing outlines and adding details.

Wax and oil pastels are soluble in organic solvents such as paint thinner and turpentine.

## Water-Soluble Pencils

Water-soluble pencils are just like color pencils, but their water-based agglutinate allows you to work on the drawings made with a brush and water after the lines have been drawn. There are also water-soluble sticks that are not in a wood sheath, and that make a thicker line than the color pencils.

## Oil-Based Pastels

These are also known as oil crayons and are agglutinated with a medium (wax) that is not water-soluble, but that can be diluted with paint thinner, turpentine, and the like. They can make quite an intense line, but they mix and get dirty quite easily, and they never fully dry, especially if the room temperature is too high.

## Color Pencils

The lead of a color pencil is composed of a pigment agglutinated with an oily medium similar to wax. The agglutinate allows you to sharpen the point with no problem, but it will not carry as much pigment as pastel pencils. Thus, color pencils create lines that are of a somewhat lower intensity and of quite limited weight or thickness. They are a good drawing medium when you are working in small and medium formats, and on a white or very light support.

Thick crayons can often be diluted with water, which means they can be used like watercolors.

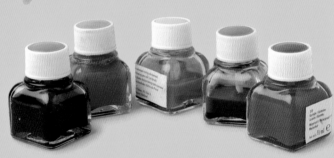

### India Ink

India ink is a mixture of very fine powder made from carbonized wood, agglutinated with a substance that makes it water-soluble while it is liquid and waterproof after it has dried. Ink can create the most precise and detailed drawings of any medium because the pen used to draw has a very fine point. Because of this precision, it is possible to work with very small formats without losing any detail. In addition, India ink has an incomparable strength and graphic quality, a pure black that clearly stands out on an immaculate white background.

There are many different kinds of color ink. It is true that the colors are very bright, but it is also a fact that they are not very resistant to long exposure to light.

Sometimes small bottles of color ink are sold under the name of liquid watercolors. They are not watercolors, but inks of vibrant but not very permanent colors.

### Kinds of Ink

Traditional India ink is always black, dense, opaque, and very resistant to light and the passage of time. It can be lightened by diluting it with water, but it is waterproof after it has dried. The ink is sold in small containers and bottles of different sizes. Sepia ink, traditionally known as "bistre," is brown ink that is commonly used by artists because of its warm color and because many shades can be made with it by adding a small amount of water.

Writing inks, which are used for filling fountain pens, are more fluid and not as dense as India ink. The most common colors are black and blue. For artists, these inks are interesting because they can be more easily diluted with water (tap water is fine) to create a wide range of different tones when used with a nib or reed pen. Color inks, which nowadays are available in a wide range of colors, are quite transparent, and are manufactured using very strong and bright colorants, most of which are aniline dyes. Unfortunately they are extremely sensitive to light and they will fade over time.

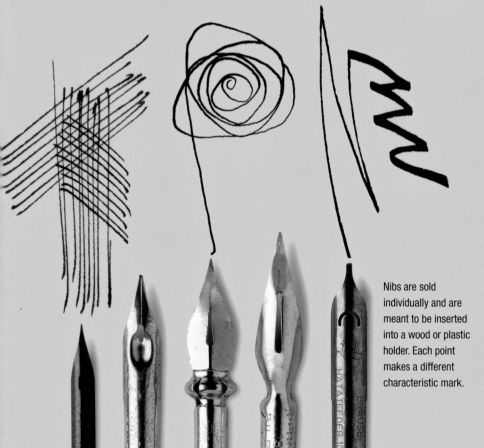

Nibs are sold individually and are meant to be inserted into a wood or plastic holder. Each point makes a different characteristic mark.

### Ways of Drawing with Ink

In the old days, quills were the universal tool for drawing and writing with ink. Nowadays very few artists use them, preferring metal nib pens and modern writing and drawing tools; however, some continue to use the traditional reed pen to create more rustic or "picturesque" results. We must include the brush along with these utensils, both the conventional and the Chinese types, which considerably increase the artistic possibilities. No matter which drawing tool you choose, paper is always used as the support.

### The Pen Nib

The pen nib is a piece of metal, smaller and more flexible than fountain pens, that is inserted into a metal or plastic handle or pen holder. The point of the drawing pen has a cut or incision in the middle that forms a small channel where the ink is held and from where it descends to the point as you draw. You can make a fine line by lightly dragging the pen across paper; if you apply more pressure the nib will open and allow more ink to flow, thus making a heavier or wider line. This allows the artist to control the lines as he or she wishes.

Drawing nibs range from stiff to flexible, and just like pencils, the harder the point the finer the line. It is best to use a medium stiff pen. There are also a number of pens for writing and calligraphy that make a variety of different strokes that are useful for specific effects.

### Reed Pens

The reed pen is handled in exactly the same way as a nib pen, but it creates more rustic and robust drawings. It consists of a length of dry bamboo with a point carved on one end. Whereas the lines drawn with a nib pen are purely black, a reed pen can make lines in a wide range of gray tones. In addition, the lines drawn with a reed are quite course and less precise than those of a nib pen, and it is useless to try to control the width of the line because it is much softer than the nib and it requires you to apply a lot more pressure. The point of the reed pen wears with use, and its line becomes wider over time. These and other factors make the reed pen an appropriate tool for sketches and very direct and spontaneous drawings.

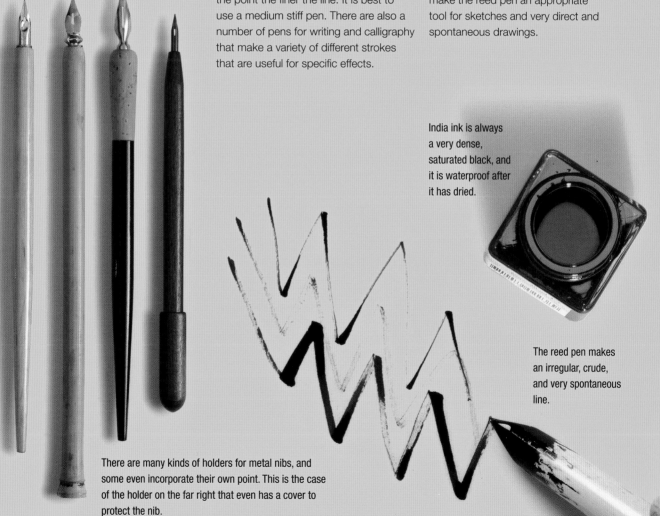

India ink is always a very dense, saturated black, and it is waterproof after it has dried.

The reed pen makes an irregular, crude, and very spontaneous line.

There are many kinds of holders for metal nibs, and some even incorporate their own point. This is the case of the holder on the far right that even has a cover to protect the nib.

## Markers

Markers consist of a cylindrical container filled with a special fast-drying ink, into which is inserted a felt wick attached to a pointed tip or head of the same felt material, or nylon. The ink keeps the tip wet until the container has been completely emptied. Fat markers are usually felt and have a chisel point, which can be used to draw thin or thick lines depending on the angle that the marker is held to the paper. These points become softer with use until it is nearly impossible to draw a fine line with them. Most fine-tipped markers have points made of nylon or another acrylic material. Markers with acrylic tips usually are for drawing fine lines and they rarely soften, but they often suffer from an irregular flow of ink and must be left to "rest" for a few moments, upside down with the cap in place.

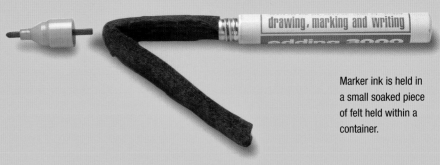

Marker ink is held in a small soaked piece of felt held within a container.

## Varieties

Markers come in many shapes and sizes. Some have more transparent ink than others, and there are even some water-based markers that are totally opaque. For our purposes, all you need are a few markers with round tips, neither fine nor thick, with black ink.

The reason that we must use several markers is that the lines lose their intensity and acquire a tone that works well for making light shadows. Therefore a new marker should be used for blacks, slightly used markers can be used for the medium grays, and much used markers will supply the light gray tones.

Markers are easy tools to use, and they do not require special techniques. As an artistic tool, they fall between the pencil and the nib pen. Like a pencil, they can be used to create middle tones of varying intensities, using lines but not necessarily hatching. Nib pens are used because they make very defined and striking blacks.

Markers are available with many different tips and can make very fat lines or very precise thin ones.

### Fountain Pens

Fountain pens need no explanation because everybody has used one at some point. Their great advantage as a drawing tool is their convenience: you can carry them in a shirt pocket and draw with them anywhere, in the city or in the country. They require no special care except refilling when they run out of ink.

Most modern fountain pens use ink cartridges, which makes them easy to use.

This type of drawing pen makes a wider line than writing pens, its nib is stiffer and stronger than that of most fountain pens, but has a certain amount of flexibility that allows it to make lines of various widths. Any paper can be used for drawing with fountain pens except for the cheapest and most absorbent ones.

### Ballpoint Pens

In addition to being a writing instrument, a conventional ballpoint pen can also become a useful tool for making artistic drawings. It is mainly used for drawing or sketching onsite, since a ballpoint pen can be taken anywhere and will draw on any kind of paper.

Some markers are water-based and their lines can be diluted.

There are fountain pens manufactured specifically for artists who want the quality of an ink drawing without having to use containers and nib pens.

Ballpoint pens with different widths make a smooth continuous line of constant width and can be very useful for making sketches.

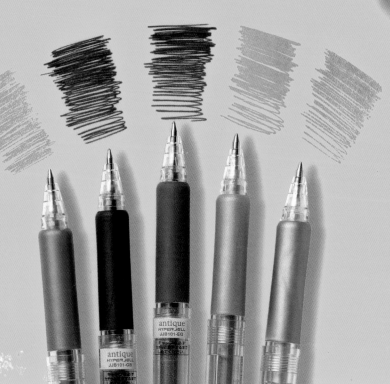

### Other Writing Utensils

There are many types of drawing tools available that are difficult to classify: ballpoint pens with very fluid ink, roller ball markers, and extra fine point pens. There are now many varieties of writing ink as well. Most of these materials can be perfectly adapted to drawing and show characteristics that are very similar (if not identical) to those of ballpoint pens and markers, so they do not require further explanation.

### A Great Variety of Qualities and Textures

There are basically two types of paper for drawing: artisanal and industrial. Of course, each of these two categories offers a great variety of qualities and textures depending on the raw materials used in its manufacture and its finishes, as well as its weight, measured in pounds or grams per square meter. As for its texture, drawing paper is available with texture or smooth. The textured papers are useful for working with graphite pencils, pastels, sanguine, and charcoal, whereas the smooth finishes are best for drawing with pen and ink, although you can also create nice gradations with graphite or lead pencils.

### Types of Paper

Papers with fine textures are best for making "velvety" gradations; therefore, they work well with soft graphite pencil and color pencils.

Medium texture, or medium grain, papers are recommended for drawing with sanguine and pastels, although you can also work well with watercolors. Papers with a heavy texture, including watercolor papers, have quite a rough texture, are heavier, and have sizing to control absorption. Interesting effects can also be created using some pencil techniques with this category.

In any case, these are just referential guidelines on which you can base your experiments and find for yourself the appropriate materials for your own specific interests and needs.

The color and texture of the paper contribute expressive elements that strengthen your drawing. These elements become part of the drawing and create very interesting effects of light, volume, and tone.

### Paper for Drawing with Graphite and Color Pencils

Paper used for drawing with graphite and color pencils should be smooth, but for graphite it can also be slightly textured. The smoothness and consistency of the line breaks up on textured paper.

Charcoal drawings require a paper with texture that will hold the charcoal that is deposited with each stroke.

Paper used for graphite drawings should be smooth, or at least not very textured, so that the continuity of the lines is impeded.

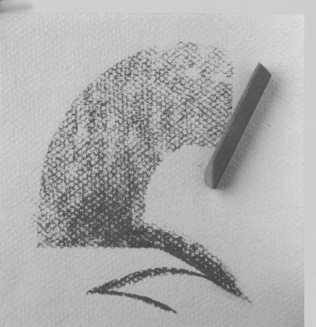

Papers used for hard and soft pastels should always have a certain amount of texture so that the pigment will easily adhere to it.

## Paper for Drawing with Charcoal and Pastels

Laid paper, white and in colors, is generally used for vine charcoal and compressed charcoal. Its texture is very useful, especially for the expressive possibilities using the latter form. Color paper for pastels has a more or less rough texture on one side and a medium texture on the other. Artists can use either side according to their individual needs. Its texture is also ideal for use with charcoal.

## Papers for Drawing with Ink

The ideal paper for drawing with ink pen is smooth, without texture, and not very absorbent. The sharp point of the nib pen will catch on any other paper, and will not glide easily across it. Additionally, the paper should possess a certain hardness to stand up to repeatedly going over lines, offering a durable, totally smooth base. Any smooth paper will fulfill the requirements of drawing with a nib pen.

## Caring for Paper

Paper is susceptible to changes in weather and to humidity, so it is a good idea to protect it from these environmental effects, preferably in wood chests with wide drawers or in portfolios that are larger than the sheets of paper. It should never be rolled up; this deforms the paper and its fibers are moved out of position. It also best to store drawings in a flat rather than vertical position. Above all, you must be sure that the paper is dry before you put it away to avoid the appearance of streaks of humidity on its surface.

Manufacturers of fine arts supplies make special paper for drawing with ink.

Ink drawings require the use of smooth paper.

Pastels adhere best to paper with a certain amount of texture.

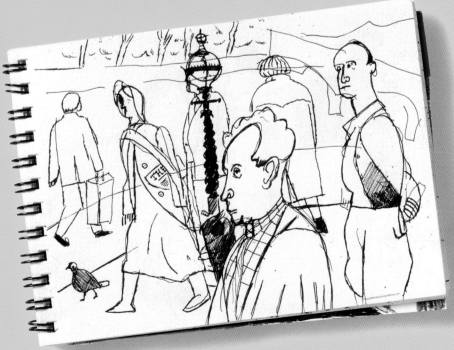

Number of the technique.

Advanced level.

Note on level and materials used.

Advice and tricks.

The direction of important lines.

**LEVEL OF DIFFICULTY**
★ ★
**TOOLS**
White, Yellow, Red, Blue, and
Green Pastel Sticks
**SUPPORT**
90 lb (200 gr) Medium Textured Green Paper

In the following exercise, you will see how bright saturated colors
harmonize with other vibrant tones in a drawing, rather than clas...
Here spring flowers are the subject of the drawing.

**1.** Start with a few pencil lines as guides;
then draw the flowers and the stems
with green and red pastel sticks without
applying too much pressure or making
very heavy lines.

**2.** Add light strokes of red, yellow, and
white on two of the flowers, and then rub
and blend the colors with your finger.

**3.** Leave some of the colors un...
that is to say, the green leaves,
will contrast with the flowers. T...
the contrast is not only the col...
texture.

**4.** Finally, surround
the leaves and
flowers with blue
pastel to unify the
drawing and create
a strong contrast
against the bright
green of the paper.

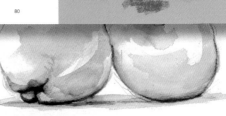

80

---

**LEVEL OF DIFFICULTY**
★ ★
**TOOLS**
4B Water-Soluble Graphite Pencil
Round Natural Hair Watercolor Brush
**SUPPORT**
120 lb (290 gr) Heavy Textured Paper

Water-soluble graphite is a variety that can be dissolved in water and can
be spread and worked with a brush. You use it in the same way as any
other pencil, and the tone and intensity are the same. They are available
with leads of different hardness. Here you will use a soft lead because
it leaves a greater amount of graphite on the paper, which will make a
darker tone when it is wet.

**1.** The initial
sketch should be
simple, and you
will continue going
over the lines as
you work so that
later there will be
graphite to work
with.

Water-soluble pencils can
also be used by dipping
the point in water. This
approach will create a much
darker line because the
lead dissolves when it is
applied to the paper. This
can be a good alternative to
dampening the paper.

**2.** Pass a wet brush over the drawing,
which will cause the lines to dissolve and
the water to turn a gray tone that you can
use to create transparent shadows.

**3.** The darkest accents, on the
undersides of the fruit and in some details
on the leaves, can be added by going
over the areas while they are still damp
from the effects of the brush.

**4.** Here you can see how it is possible to
create dark details by working on damp
paper: the line spreads slightly because
of the dampness, which also increases its
intensity.

**5.** Create the ...
on them after ...
dampened wi...
contrasts are ...
clarity of the li...

**7.** Add some
shading
underneath th...
pieces of fruit t...
represent their
shadows on the
table. This exercise
illustrates the
habitual approach
to working with
water-soluble
graphite: the light
lines and shading
contrast with
accents that are as
dark as the pencil
will allow.

80

Beginner level.

Pastel and Wax Crayons / **Pastel and Erasing**

DIFFICULTY

...and Dark Blue

...

...

...r) Medium
...ite Paper

Pastel can be erased, but not as easily as natural charcoal. In this exercise, you will make a drawing with a stick of pastel and use a rubber eraser to make white lines in the blended blue pastel.

**1.** Color the paper with wide strokes of the two blue pastel tones, the darker at the bottom and the lighter above.

**2.** Rub the pastel with the rag to create a uniform tone. The lower area will be darker but with a very smooth texture.

**3.** Use a corner of the eraser to "draw" white lines that are actually the color of the paper. The eraser must be made of rubber, harder than the usual kneaded eraser that is used when drawing with charcoal.

**4.** Add some final lines with the dark blue pastel to add depth to the drawing. The resulting sailing ship was made without a great amount of effort.

81

Step number.

Description of the step.

# The 101 Techniques

This section is organized in six large blocks or monographic chapters, each of which consists of 15 exercises. The first block is dedicated to the most basic elements and is mainly directed toward beginners. Each exercise incorporates first a list of materials used: pencils, charcoal or pastel sticks, pens, and inks, as well as the type and quality of paper. It also indicates the level of difficulty with one or two stars. One star is used for the elementary level, meaning that the approach is within the ability of the beginning artist; two stars are used for the advanced level, which means that the exercise is directed toward artists with somewhat more experience.

The development of the drawing is related in step-by-step sequences in one or two pages, and the explanation of each step is accompanied by illustrations so the reader can follow the process as closely as possible.

**LEVEL OF DIFFICULTY**
★
**TOOLS**
Graphite Pencil
Blue Color Pencil
**SUPPORT**
80 lb (180 gr) Lightly Textured Paper

Blocking in is the most basic method of drawing. It consists of creating the structure of the object that you wish to represent with correct proportions. To simplify this method even more, we have chosen, as the first exercise in this lesson, an object that is itself already quite schematic and basic: a chair.

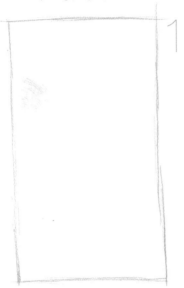

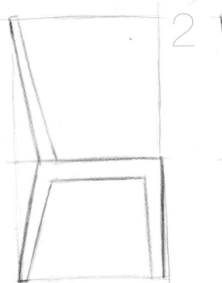

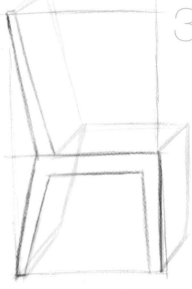

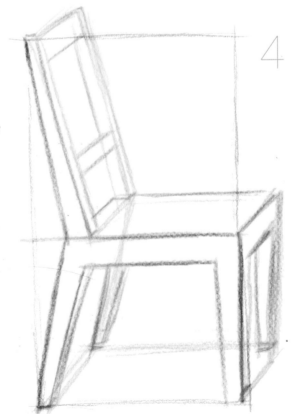

**1.** All simple objects can be blocked in as a basic shape. The proportions of this chair (its height with respect to its width) can be established using a rectangle.

**2.** Within the rectangle indicate the height of the chair, and from there you can draw its profile, making sure to adjust the inclination of the back and the legs in the foreground with respect to the verticals of the rectangle.

**3.** You can easily suggest a sense of perspective by just projecting some diagonal lines, parallel to each other, beyond the corners of the rectangle.

**4.** Draw the other two legs from the previously made diagonal lines, and then the plane of the seat and the back of the chair.

**LEVEL OF DIFFICULTY**
★

**TOOLS**
Hard Red and Ochre Pastels

**SUPPORT**
90 lb (200 gr) Medium Textured Paper

When drawing simple objects, and, more importantly, symmetrical objects, simple geometric shapes can be a great help. In this drawing, you will use a rectangle and a circle combined in such a manner that you can almost immediately recognize a bottle in the rectangle. This kind of blocking in (as simple as possible) is the easiest way to create representations of objects.

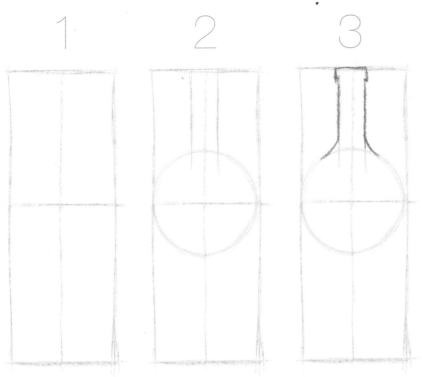
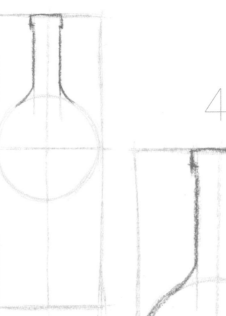
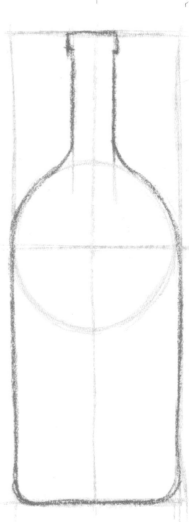

**1.** Again, start with a rectangle whose proportions coincide as closely as possible with the height and width of the real bottle. Divide the rectangle into four parts: in half vertically, and in half horizontally.

**2.** Draw a circle in the center of the rectangle as marked by the crossed lines. This circle marks the outline of the shoulders of the container.

**3.** Use the red pastel to mark the final outline of the bottle: start with the neck of the bottle, where you can first block in a small rectangle at the top of the circle.

**4.** This is the finished drawing. The explanation is much longer than the process, since doing it does not take very much time, as long as you have drawn the correct proportions of each geometric figure.

**LEVEL OF DIFFICULTY**
★

**TOOLS**
Hard Green, Red, and Light Blue Pastels

**SUPPORT**
90 lb (200 gr) Lightly Textured Paper

Even objects with irregular outlines, which are most things that have not been manufactured by human beings, can be reduced to a very basic outline. This exercise is a good example of that; here we show you the outline and then the drawing of a tree, using circles and a few added lines to indicate the treetop, the trunk, and the branches.

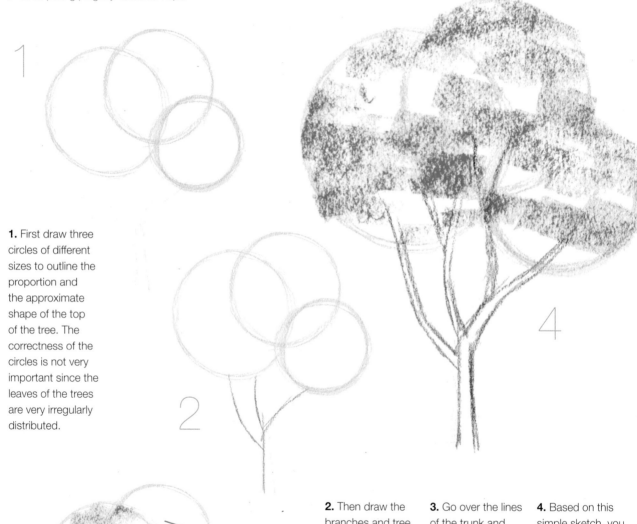

**1.** First draw three circles of different sizes to outline the proportion and the approximate shape of the top of the tree. The correctness of the circles is not very important since the leaves of the trees are very irregularly distributed.

**2.** Then draw the branches and tree trunk with a few curved lines.

**3.** Go over the lines of the trunk and the branches, and add some color to the dense foliage of this simple tree to suggest the presence of leaves.

**4.** Based on this simple sketch, you could continue adding details; for our purposes, this sketch is enough.

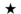

**LEVEL OF DIFFICULTY**
★

**TOOLS**
Green, Orange, Red, and Blue
Color Pencils

**SUPPORT**
80 lb (180 gr) Lightly Textured Paper

When you are blocking in a group of objects, you can usually block in the largest of them, or else block in an imaginary object that contains them all. In this case, you will first draw the geometric shape of the basket that contains the fruit. Then you can insert each piece of fruit using spheres of different sizes.

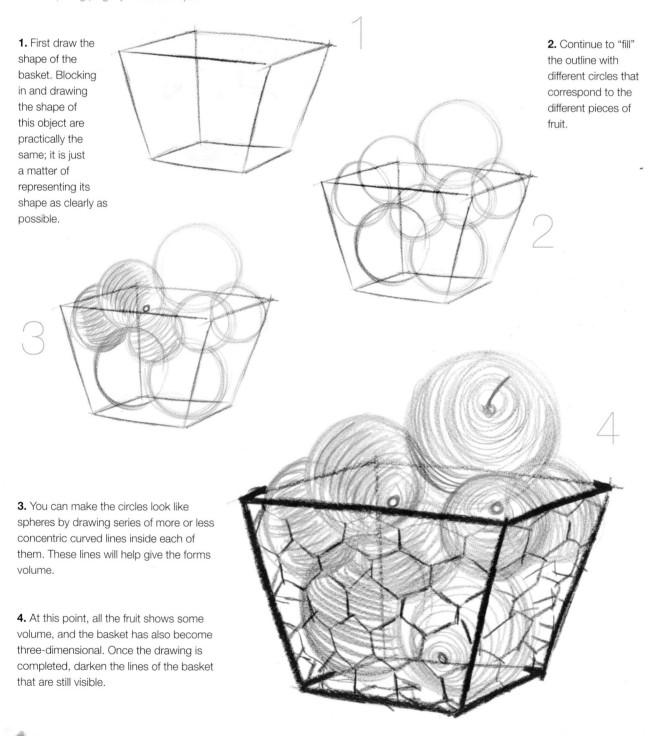

**1.** First draw the shape of the basket. Blocking in and drawing the shape of this object are practically the same; it is just a matter of representing its shape as clearly as possible.

**2.** Continue to "fill" the outline with different circles that correspond to the different pieces of fruit.

**3.** You can make the circles look like spheres by drawing series of more or less concentric curved lines inside each of them. These lines will help give the forms volume.

**4.** At this point, all the fruit shows some volume, and the basket has also become three-dimensional. Once the drawing is completed, darken the lines of the basket that are still visible.

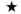

**LEVEL OF DIFFICULTY**
★

**TOOLS**
Yellow, Violet, Pink, Red, and Blue
Color Pencils

**SUPPORT**
80 lb (180 gr) Lightly Textured Paper

Composing a drawing means distributing its parts in an orderly manner in a limited space that is usually the space of the paper. The size and proportion of each part should be based on the format of the support. Composition has a lot to do with blocking in: the initial geometric forms must be organized in a way that each one of the objects and zones that make up part of the subject of the drawing are correctly placed.

**1.** The first compositional lines lay out the most important areas of the subject in the space of the paper using very general partitions that nearly occupy the entire paper.

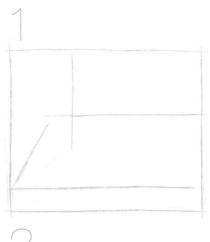

**2.** The pink lines correspond to the blocking in of the objects themselves, which are determined by the compositional lines.

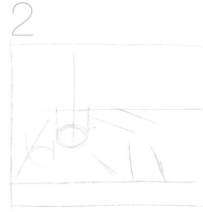

**3.** After adjusting the basic dimensions of each object (height and width), it is easier to block them in within the context of the composition.

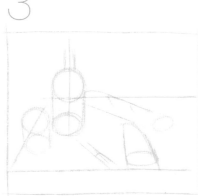

**4.** Draw the final outline of each object with a red pencil to finalize its particular shape.

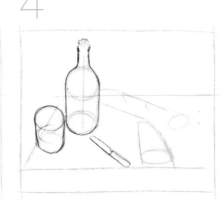

**5.** Now you should better understand the lines of the composition: these lines initially defined the plane of the table, and using them you can add the shape of the skirt of the tablecloth.

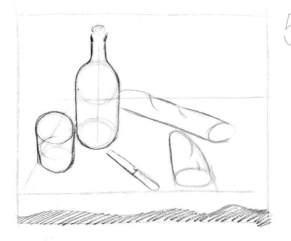

6

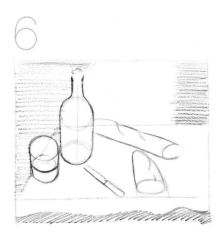

7

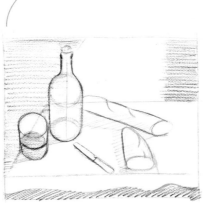

Color pencils, which have softer leads than graphite pencils, make a slightly wider line than normal pencils unless you sharpen them often while you are working.

**6.** For an artist, the light and shadows are also objects that require their own composition. These parallel horizontal hatch lines accurately suggest their distribution.

**7.** The objects contain their own distribution of light and shadows, which should be adjusted to the general organization of the composition.

8

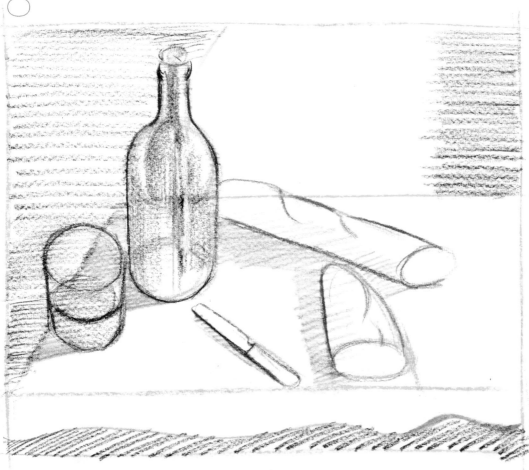

**8.** In the final work, the hatch line shading darkens and gives form to the objects in the picture while the drawing is still in its initial phase. At this point, you can consider that the composition of this subject is finished.

**LEVEL OF DIFFICULTY**
★

**TOOLS**
Violet, Pink, and Green Color Pencils

**SUPPORT**
80 lb (180 gr) Lightly Textured Paper

Foreshortening is a view of an object with depth. In reality, almost all views of an object are foreshortened, but this is not usually a problem. In this exercise, you will represent the foreshortening of a fruit bowl: the circle of the upper part looks like an oval. This is a typical representation of objects of this kind, which will serve as an introduction to blocking in and representing other more complex forms.

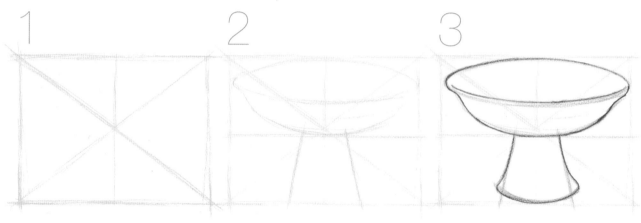

**1.** To compose the drawing, first make some divisions on the piece of paper and locate the center using the crossed diagonal lines.

**2.** Draw the bowl of the fruit stand on the upper part of the composition centering it symmetrically on the sheet of paper with an oval whose limits are the sides of the upper rectangle.

**3.** The compositional lines have taken us this far, which is nothing less than a foreshortened view of the fruit bowl.

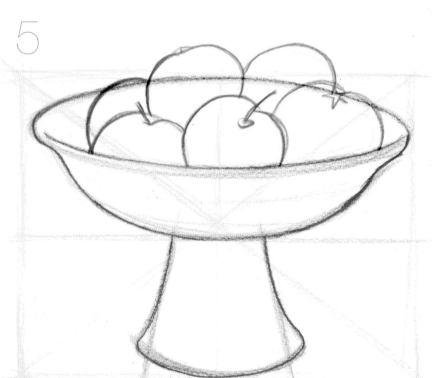

**4.** Place some pieces of fruit in the bowl, observing the size and position from your point of view.

**5.** The result is a very simple representation based on the basic forms you chose when making the drawing.

**LEVEL OF DIFFICULTY**
★ ★
**TOOLS**
Brown and Red Color Pencils
**SUPPORT**
80 lb (180 gr) Lightly Textured Paper

Organic forms in general, and animals in particular, are blocked in using curved shapes that are very often irregular. It is a matter of using curved arcs of different sizes, composed in a manner that suggests the general proportions of the model. These arcs can suggest the outlines while avoiding sharp angles that are never visible in living creatures.

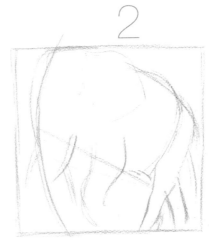

**1.** First draw a square that allows you to approximately block in the proportions of the elephant; then draw some curves to enclose its shape in the front and the back.

**2.** Add new curved lines inside the space enclosed by the previous arcs to approximate little by little the anatomical shapes of the animal.

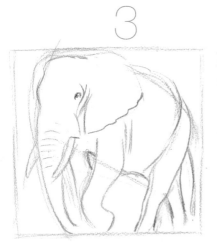

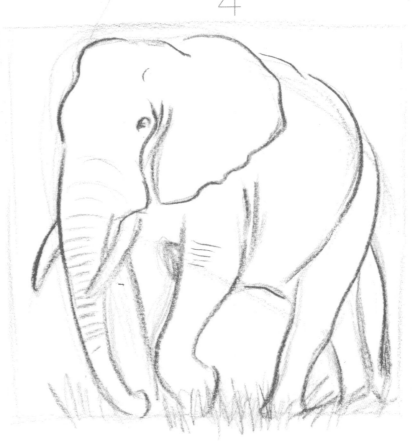

**3.** As these shapes get nearer to the form of the elephant, darken the lines that can be considered definitive, and little by little you will construct the form of this beautiful animal.

**4.** Now the elephant can be finished with a few lines that consolidate the successive additions to the outline.

**LEVEL OF DIFFICULTY**
★ ★
**TOOLS**
Graphite Pencil
Yellow, Orange, and Red Hard Pastels
**SUPPORT**
90 lb (200 gr) Medium Textured Paper

Once an artist gains some experience with blocking in, he or she will begin to understand that all natural forms can be reproduced based on a few basic shapes and a simple system of compositional divisions. The subject of the human figure becomes much more accessible, although here we address its most challenging aspect: the portrait.

**1.** This sketch can be applied to most portraits: a wide oval with divisions corresponding to facial features marked inside. The crossed lines in the middle, which you should place approximately in the center of the oval, indicate the height of the eyes and the bridge of the nose. The lower mark shows the line of the mouth.

**2.** The eyes are curves that contain circles in the middle; the drawing of the nose is also made with curves and circles. The hair partially covers the oval of the face on both sides, and falls to nearly the line of the eyes along the bangs.

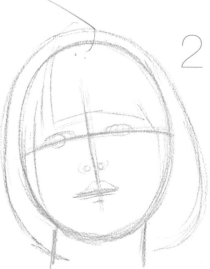

**3.** After the lines have been defined and are accurate based on the initial sketch, they can be darkened.

**4.** To finish you just have to darken some of the lines, those that most clearly determine the facial features. You can gradually and carefully go from the general outline to a detailed representation of the likeness.

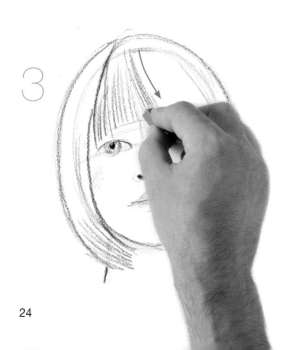

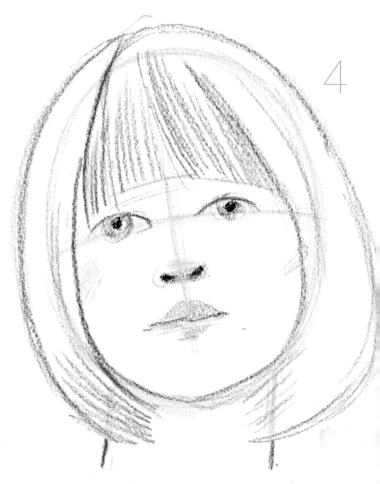

**LEVEL OF DIFFICULTY**
★ ★

**TOOLS**
Yellow and Red Hard Pastels

**SUPPORT**
90 lb (200 gr) Medium Textured Paper

Hands are perhaps the most difficult anatomical feature to draw because of the number of joints in them and the richness and variety of the movements they can make. Nevertheless, just like other subjects and motifs, they can be resolved using the same methods applied up until now: a good outline is the solution to any drawing, no matter how complicated it seems at first.

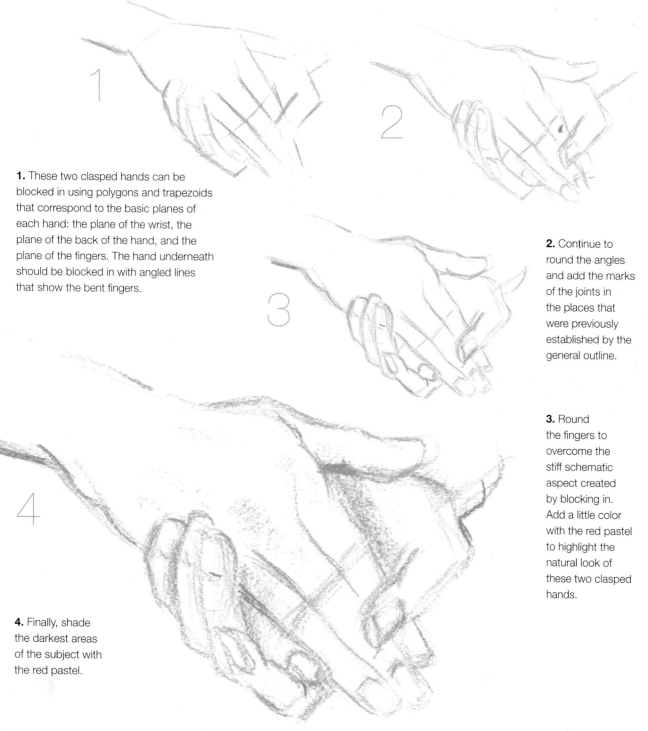

**1.** These two clasped hands can be blocked in using polygons and trapezoids that correspond to the basic planes of each hand: the plane of the wrist, the plane of the back of the hand, and the plane of the fingers. The hand underneath should be blocked in with angled lines that show the bent fingers.

**2.** Continue to round the angles and add the marks of the joints in the places that were previously established by the general outline.

**3.** Round the fingers to overcome the stiff schematic aspect created by blocking in. Add a little color with the red pastel to highlight the natural look of these two clasped hands.

**4.** Finally, shade the darkest areas of the subject with the red pastel.

**LEVEL OF DIFFICULTY**
★
**TOOLS**
Blue and Red Color Pencils
**SUPPORT**
80 lb (180 gr) Lightly Textured Paper

**Perspective is essentially a foreshortened view of an object. Usually these would be very large objects located in open spaces, but they could also be small objects like this violin. The way that you block in these objects becomes the basis for the following perspective drawing exercises.**

**1.** The foreshortened violin fits inside this triangle that not only blocks in the shape of the instrument but also becomes the first indication of its perspective.

**2.** Insert two circles on the centerline of the triangle, making sure that they are tilted in relation to the baseline that marks the bottom of the violin.

**3.** With just these simple shapes, you can already begin to draw the actual outline of the instrument.

**4.** Using this method of blocking in, you can very accurately draw a magnificent violin with correct perspective.

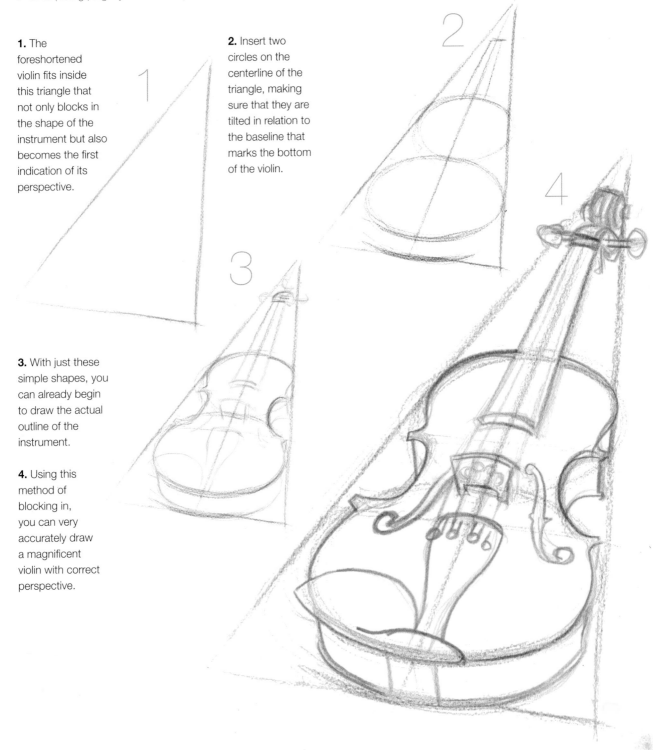

**LEVEL OF DIFFICULTY**
★
**TOOLS**
Green and Red Color Pencils
**SUPPORT**
80 lb (180 gr) Lightly Textured Paper

The vanishing point is an imaginary place that the lines of perspective move toward and where they stop. Most perspective drawings can be divided into two large groups: those that have a single vanishing point and those that have two vanishing points. This simple drawing introduces the concept of two vanishing points located at the same height but placed very far apart. This perspective is drawn from a point of view that is at an angle to the object.

**2.** Draw the frame of the glasses within the pairs of lines of perspective while maintaining the symmetry of the lenses despite the reduced size caused by the perspective view.

**1.** These glasses can be blocked in between two pairs of lines that move away as they approach the two different vanishing points. The lines start at a vertical line that is located at the nearest edge of the object.

**3.** Go over the definitive lines with a red pencil. This oblique view is referred to as two-point perspective, and acts as an introduction for the following exercise.

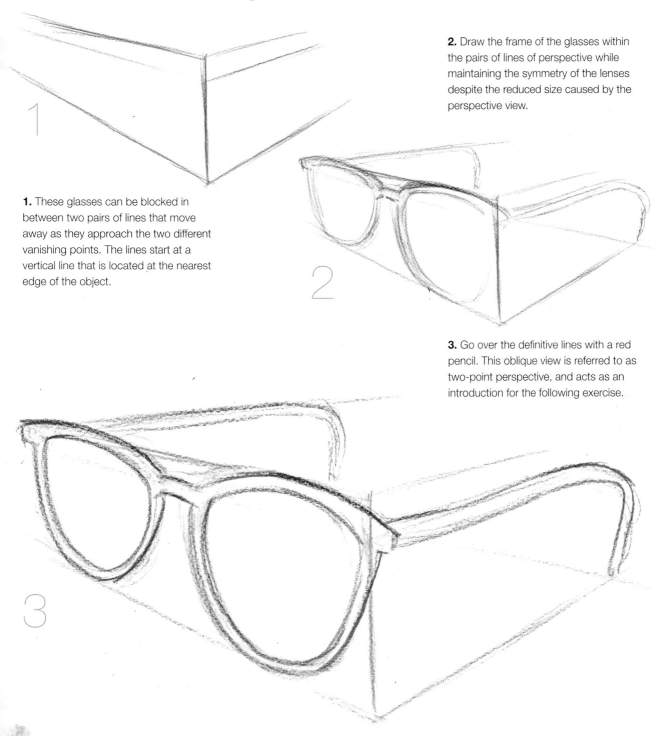

**LEVEL OF DIFFICULTY**
★ ★

**TOOLS**
2B Graphite Pencil

**SUPPORT**
80 lb (180 gr) Lightly Textured Paper

In the following example, we lay out a true case of two-point perspective: a building erected in an open space. This kind of perspective is most commonly used for buildings since they are so large that one side of the building recedes to one vanishing point while the other side of the building recedes toward a different vanishing point that is very far from the first. In this drawing, you will indicate the lines in perspective, but not the two vanishing points since they are located outside of the sheet of paper.

**1.** Start with a vertical line, from which the lines of perspective go off in different directions. In reality, these are the lines of right angles that look like they are extending diagonally toward the horizon.

**2.** The vertical lines define the edges of the different walls of the house and the roof is then defined using new perspective lines drawn higher than the previous ones.

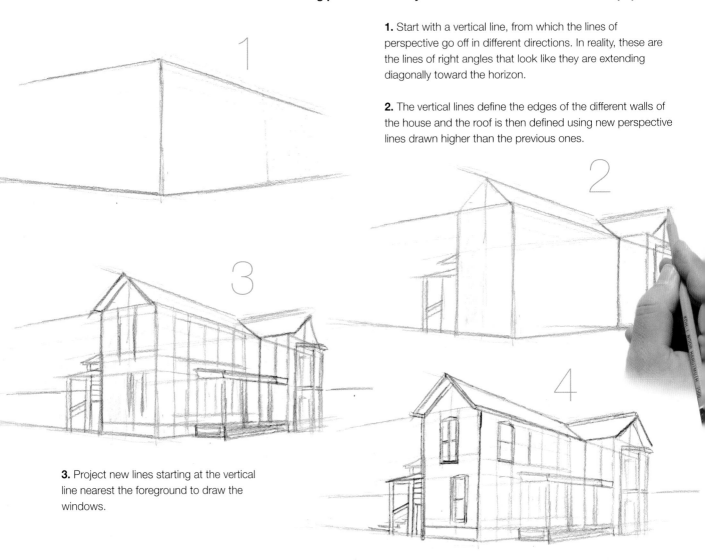

**3.** Project new lines starting at the vertical line nearest the foreground to draw the windows.

**4.** Now that you have laid out the basic dimensions of almost all the elements you can begin to define some of the outlines.

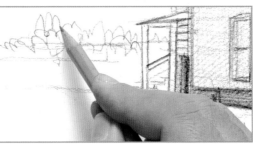

Pencils with hard leads make very fine lines, and the point can indent and even tear the paper. It is a good idea not to apply too much pressure with the pencil on the paper.

**5.** Little by little define the outlines of each detail after you have defined its shape using the lines of perspective that you have drawn.

**6.** Shading consists of lightly rubbing the pencil point on the façades that are more parallel to our point of view to darken them a little.

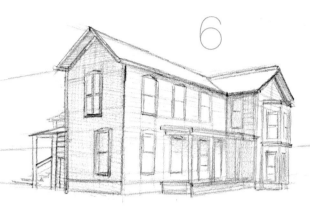

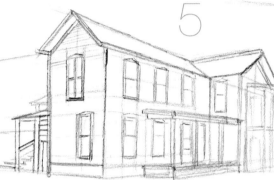

**7.** If you increase the pressure on the paper with the pencil, you will create darker areas that represent the interior of the house seen through the windows.

**8.** To finish, add a few suggestions of the landscape around the house to give some context to this exercise in developing a two-point perspective drawing.

**LEVEL OF DIFFICULTY**
★
**TOOLS**
2B Graphite Pencil
**SUPPORT**
80 lb (180 gr) Lightly Textured Paper

Shading is just a matter of darkening the lines. It is one way to organize areas with different tones so that the objects represented seem to have volume and relief. In this exercise, we will show you how to arrange these zones using a very simple method based on hatching done with parallel lines.

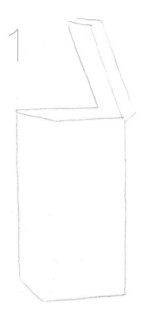
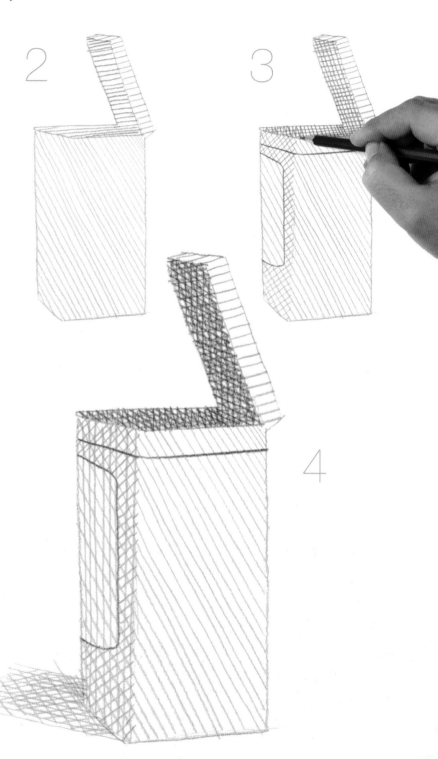

**1.** Block in the form of a box using basic shapes; draw it with a lid so that its three-dimensionality is suggested even before it is shaded.

**2.** Cover the box with parallel hatch lines of different intensity and different direction for each area of the drawing.

**3.** Now cover some of the hatch lines with a new series of parallel lines drawn perpendicular to the previous ones. The zones chosen for this will be the most shaded ones: the side of the box and its interior.

**4.** Finally, draw some new crosshatch lines on the exterior of the box, at its base, to suggest the plane that the box sits on and its projected shadow.

**LEVEL OF DIFFICULTY**
★ ★

**TOOLS**
7B Graphite Pencil

**SUPPORT**
90 lb (200 gr) Medium Textured Paper

In this exercise, you are going to use a different method of shading, based on loose strokes made on the paper with a very soft graphite lead. You should use a 7B pencil with an extra soft lead that makes a very dark line. In addition, you will use paper with a bit of texture so that its roughness will contribute to making more informal strokes.

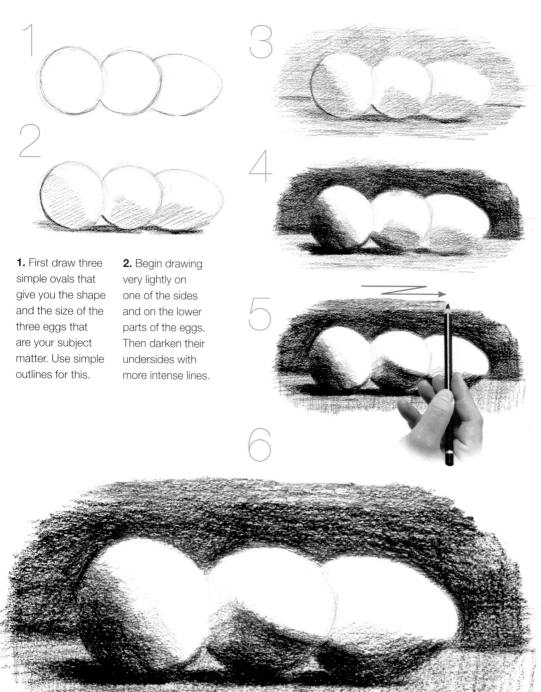

**1.** First draw three simple ovals that give you the shape and the size of the three eggs that are your subject matter. Use simple outlines for this.

**2.** Begin drawing very lightly on one of the sides and on the lower parts of the eggs. Then darken their undersides with more intense lines.

**3.** Also darken the background with light pencil lines to make the illuminated parts of the eggs stand out.

**4.** Apply the pencil in different directions to avoid making hatch lines, and increase the pressure on the lead to create darker tones in the areas of shadow.

**5.** Hold the pencil at the end and allow the point to glide across the paper to decrease the amount of pressure that you are applying. This will create a gradation in the background that moves from dark to light.

**6.** Here the drawing shows a convincing chiaroscuro in which the simple oval shape of the eggs clearly stands out in three dimensions.

**LEVEL OF DIFFICULTY**
★
**TOOLS**
HB and 3B Graphite Pencils
**SUPPORT**
80 lb (180 gr) Lightly Textured Paper

The materials used for making conventional pencil leads are graphite and clay. The leads can be soft or hard based on the amount of clay they contain: the softer they are, the darker and more intense the stroke made with them will be. In this exercise, you will be shading a subject using lines of different intensities and pencils of different hardness: a hard pencil (HB) and a soft one (3B).

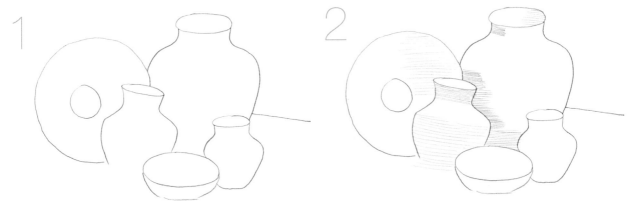

**1.** Make a simple drawing clearly showing the shape of each element: here the differentiation of each is more important than the accuracy of the drawing.

**2.** Use the pencil with the harder lead (HB) to lightly draw parallel horizontal lines on the shaded sides of the pots.

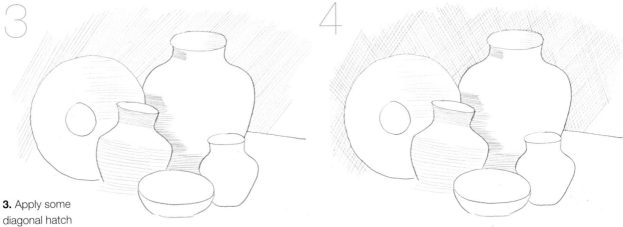

**3.** Apply some diagonal hatch lines on the background to distinguish that plane from the surfaces of the dishes during this preliminary phase of the drawing process.

**4.** To darken the background plane, make more hatch lines with the same pencil, but make them perpendicular to the existing ones.

**5.** Hard pencils make a light and precise line, which is best for starting a drawing or, as in this case, to enrich the first hatch lines in a more elaborated work.

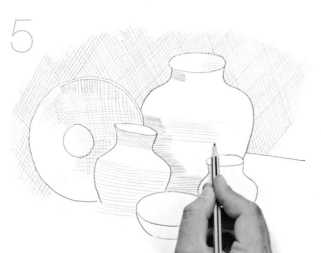

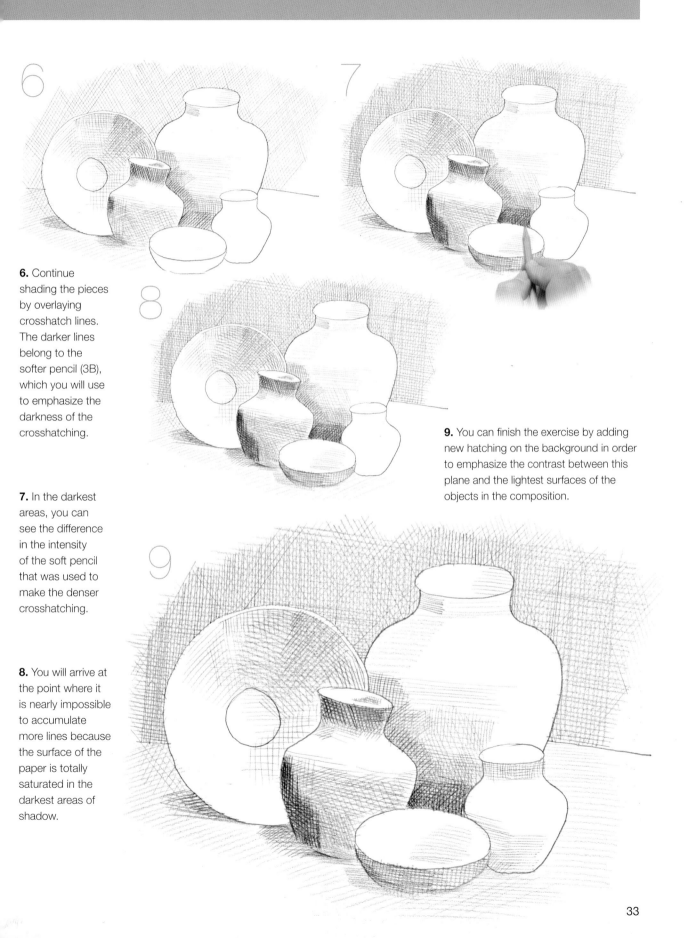

**6.** Continue shading the pieces by overlaying crosshatch lines. The darker lines belong to the softer pencil (3B), which you will use to emphasize the darkness of the crosshatching.

**7.** In the darkest areas, you can see the difference in the intensity of the soft pencil that was used to make the denser crosshatching.

**8.** You will arrive at the point where it is nearly impossible to accumulate more lines because the surface of the paper is totally saturated in the darkest areas of shadow.

**9.** You can finish the exercise by adding new hatching on the background in order to emphasize the contrast between this plane and the lightest surfaces of the objects in the composition.

**LEVEL OF DIFFICULTY**
★

**TOOLS**
HB Graphite Pencil
4B Graphite Stick

**SUPPORT**
80 lb (180 gr) Lightly Textured Paper

**1.** First draw the scene with a hard pencil (HB) to create some precise lines and some well-defined outlines in the most intricate areas.

**2.** Fill the spaces left by the drawing with very dense strokes using a soft pencil (4B) to create the darkest tone possible.

The greatest simplification of the chiaroscuro technique consists of total contrast between the white areas and the black areas. This exercise addresses this approach: you will see that graphite does not render a saturated black, only a cool tone of dark gray, but the contrast is sufficiently intense to create a clearly graphic effect.

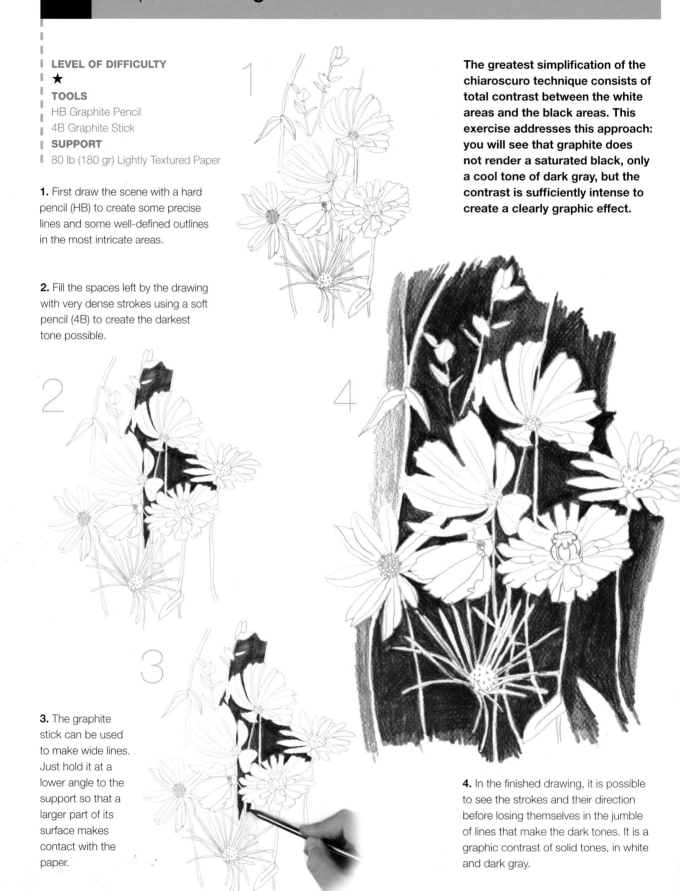

**3.** The graphite stick can be used to make wide lines. Just hold it at a lower angle to the support so that a larger part of its surface makes contact with the paper.

**4.** In the finished drawing, it is possible to see the strokes and their direction before losing themselves in the jumble of lines that make the dark tones. It is a graphic contrast of solid tones, in white and dark gray.

## LEVEL OF DIFFICULTY
★

## TOOLS
HB and 2B Graphite Pencils

## SUPPORT
80 lb (180 gr) Lightly Textured Paper

**Modeling means creating volume on a form in a way that the form seems to have relief. The following exercise consists of modeling a piece of fruit by drawing hatch lines with graphite pencils.**

**1.** Begin by drawing a pear with a hard pencil (HB), using the conventional method of blocking in. Then draw a dividing line between the light and the shadow projected on the piece of fruit.

**2.** Make hatch lines with the soft pencil (2B) on the shaded area. The parallel lines should be close enough that they create an even tone.

**3.** Continue with the soft pencil because it can be used to make a darker band along the central line that you previously drew. The result is a relief drawing, giving the pear "form."

**4.** To finish, lightly shade around the outside of the pear with the hard pencil to contextualize the drawing a little in the surrounding space.

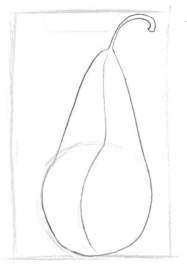

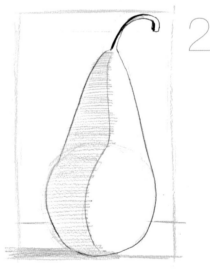

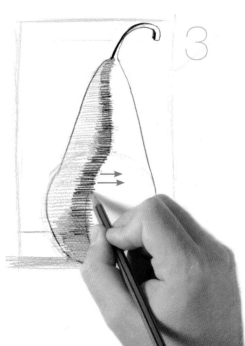

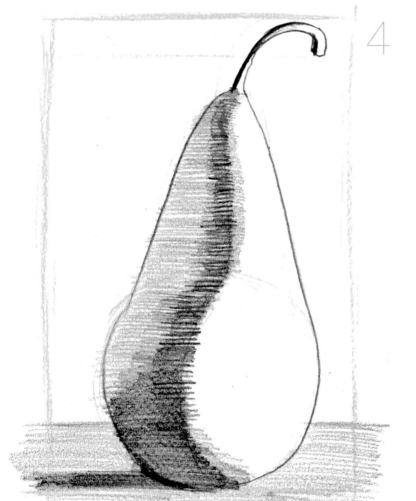

**LEVEL OF DIFFICULTY**

★

**TOOLS**

HB and 2B Graphite Pencils

**SUPPORT**

80 lb (180 gr) Lightly Textured Paper

In this exercise, you will see how rich and dense line work can make systematic shading of the forms unnecessary. The intricate architectural details in this drawing suggest its three-dimensionality and allow you to leave the line and hatching work for the empty areas.

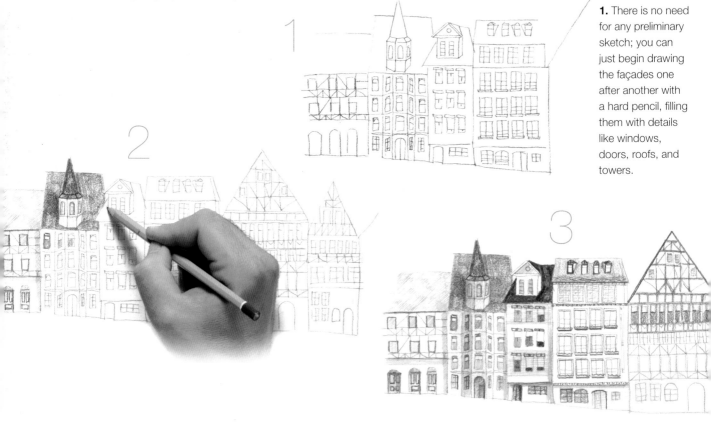

**1.** There is no need for any preliminary sketch; you can just begin drawing the façades one after another with a hard pencil, filling them with details like windows, doors, roofs, and towers.

**2.** You can use the soft pencil for details in the drawing, like frames and doors, and also darken the rooftops to create contrasting tones that add relief to the drawing.

**3.** This is how the exercise progresses: the contrasts between light and dark lines and the surface add relief to the architecture on this street.

Pencils with hard leads are very useful for making long light areas with horizontal or vertical parallel lines that are very close together. These light shadows in the sky evoke long low clouds on a winter day.

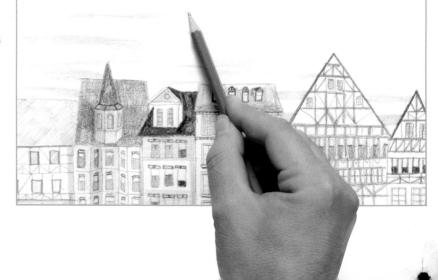

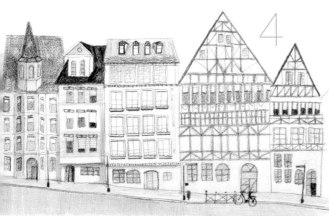

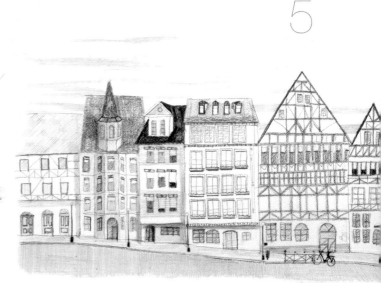

**4.** The dark details along the sidewalks were drawn with a soft pencil. The tone on the street was made by drawing very fine crosshatching with a hard pencil.

**5.** It is important for the shading in the sky to be wavy so that it contrasts with the straight lines and shapes on the façades.

**6.** It is a good idea to contrast some façades with light lines against others that have more accentuated lines because this will avoid the monotony caused by the sameness of lines and intensity.

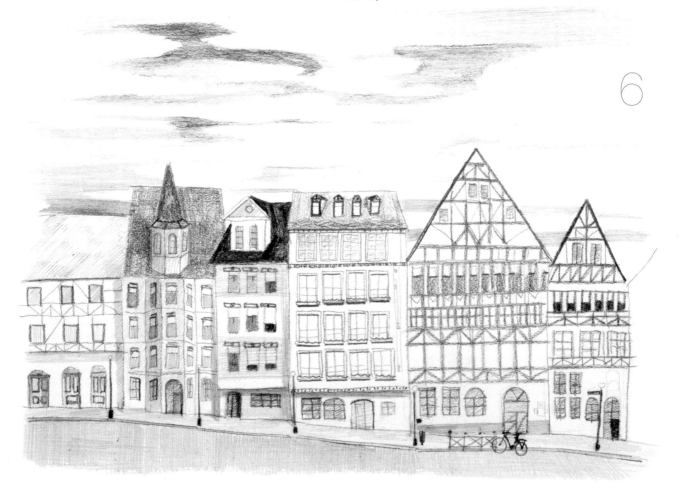

**LEVEL OF DIFFICULTY**
★
**TOOLS**
HB and 2B Graphite Pencils
**SUPPORT**
80 lb (180 gr) Lightly Textured Paper

**1.** First draw a simple outline of the tree, complete and enclosed. Use the harder HB pencil for this, drawing a continuous line without going over or emphasizing any part of the outline.

In the following technique, you will apply short pencil lines to create a suggestion of relief and even perhaps of volume that enriches the sinuous forms of the trunk and the branches of the tree. Use a hard pencil at first then a softer one later in the exercise, but do not make any changes to your working method.

**2.** Using the same pencil, draw a series of short lines or dashes in the branches, defining the relief on the branches by their placement.

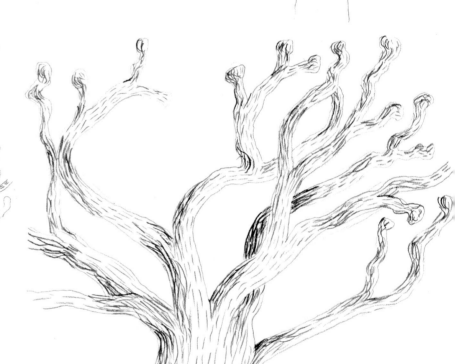

**3.** Continue to cover the inside of the silhouette with broken lines, but now use the soft 2B pencil to emphasize the lines that are on the left side of the drawing, which is the shaded side.

**4.** The different intensities of the lines suggest the shading on the tree, whereas the different directions of each line evoke the relief and irregularities of its bark.

**LEVEL OF DIFFICULTY**
★

**TOOLS**
2B and 4B Graphite Pencils

**SUPPORT**
80 lb (180 gr) Lightly Textured Paper

**The simple contrast of the intensity of the lines is the point of this exercise. The thickness of the branches is indicated with the lines, and they also create the effect of relief in the entire drawing.**

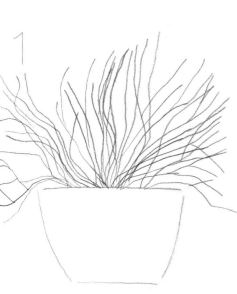

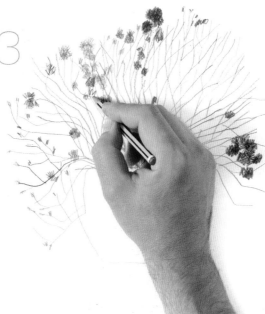

**1.** After drawing the outline of the planter, begin drawing the long and irregular lines that show the zigzag shapes of the dry stems without removing your pencil from the paper when drawing each one of them.

**2.** Press lightly the entire time you are drawing each of the little branches.

**3.** The small dry flowers that appear along the stems can be drawn with small tight lines, while applying quite a bit of pressure to the pencil.

**4.** Finally, draw some very light strokes on the surface of the planter to slightly suggest its volume and texture.

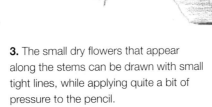

**LEVEL OF DIFFICULTY**
★ ★

**TOOLS**
HB, 2B, and 4B Graphite Pencils

**SUPPORT**
80 lb (180 gr) Lightly Textured Paper

Next, use a lion as a model to work on a graphic approach to this graphite drawing. Use different strokes, lines, and marks to define the relief, the volume, and the texture as well as to indicate all the details you can see in the animal's fur.

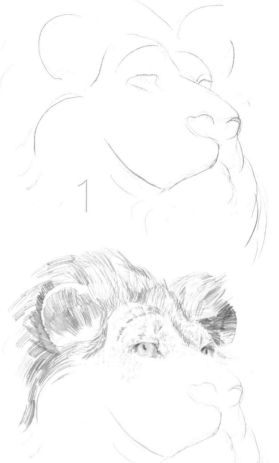

**1.** These first lines simply attempt to locate and outline the lion's features. Draw them with the softest (4B) pencil.

**4.** Apply longer, more vigorous strokes on the mane making parallel lines that curve in different directions to represent the waviness of the fur. Now alternate the 2B and 4B pencils, the latter for the darkest parts of the ears.

**2.** Use the HB pencil to cover the areas of the eyes with small-size marks (dots and hatch lines) to indicate the fur of the lion, suggesting the texture and anatomy with the directions of the lines.

**3.** Alternate your HB and 2B pencils while you make some very light textures, denser than the previous ones, defining the texture and the relief on the nose.

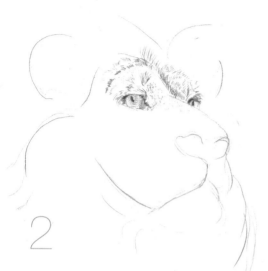

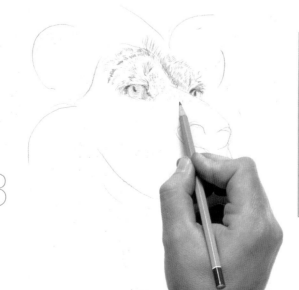

In drawings created by accumulating marks and lines, the blocks of dark tones should consist of linear strokes to avoid breaking up the graphic texture of the work with blocks of homogenous tones.

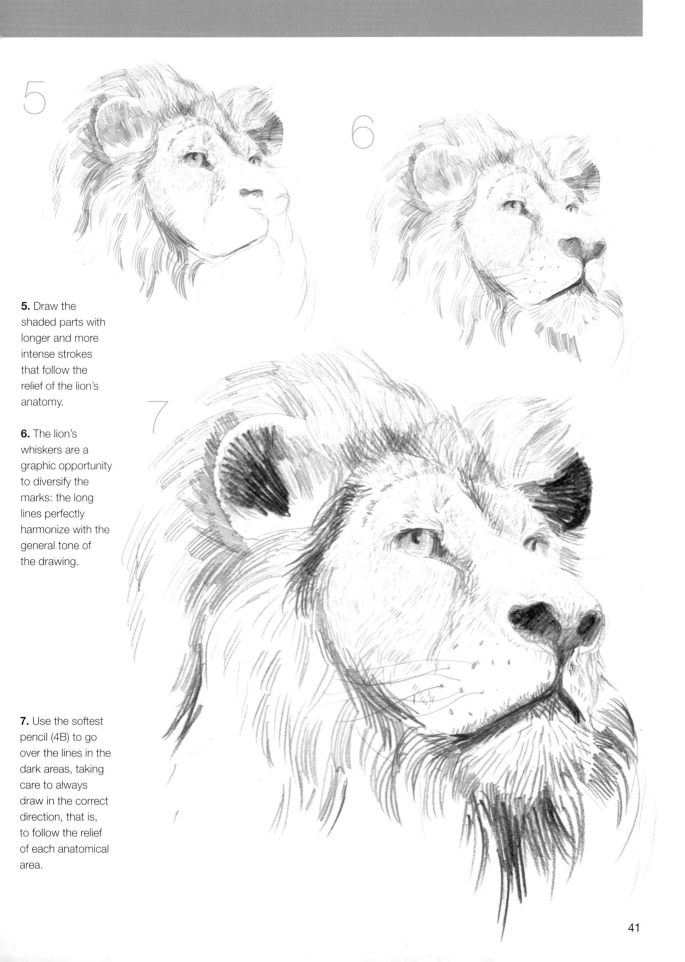

**5.** Draw the shaded parts with longer and more intense strokes that follow the relief of the lion's anatomy.

**6.** The lion's whiskers are a graphic opportunity to diversify the marks: the long lines perfectly harmonize with the general tone of the drawing.

**7.** Use the softest pencil (4B) to go over the lines in the dark areas, taking care to always draw in the correct direction, that is, to follow the relief of each anatomical area.

**When you apply the side of the lead to the paper, the result is a wide line with blurred edges. If the lead is soft, you can adjust the intensity of the stroke by applying more or less pressure on the paper with the lead. In this exercise, you will create shading using this simple method so that the shadows are light and progressive and do not show any evidence of lines.**

**1.** First draw the model: a branch of a lemon tree with two lemons and some leaves. The drawing should be a simple outline.

**2.** Shade the lower sides of the fruit by applying the side of the lead to the paper and rubbing with less and less pressure as you move away from the most shaded part.

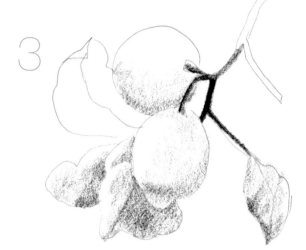

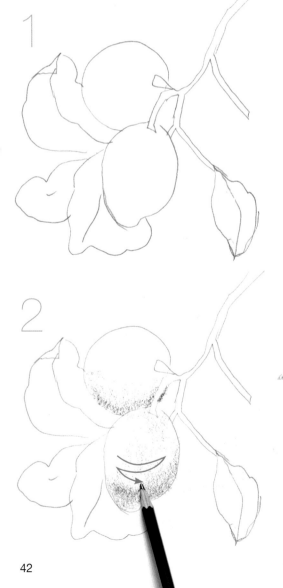

**3.** Use the point of the pencil and press until you make the darkest possible line to draw the darkest parts of the branches.

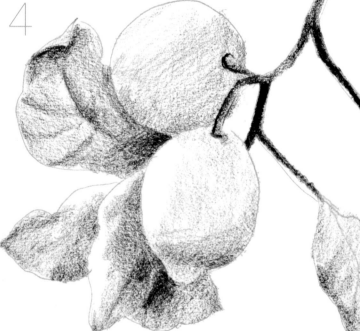

**4.** Continue shading with different tones to finish the drawing. Do not change the pencil at any time; just change the pressure of the pencil on the paper.

**23** Graphite / **Graphite Stick**

**LEVEL OF DIFFICULTY**
★

**TOOLS**
HB Graphite Stick

**SUPPORT**
90 lb (200 gr) Medium Textured Paper

**Graphite sticks are rectangular media that can make very wide marks and, if you use an edge, straight strokes. It is not at all easy to draw lines with them, but in this case that is not important. You are not going to draw lines, but you will be making some very wide strokes for shading**

**3.** All of these marks were made the same way: dragging the stick on the paper while applying different amounts of pressure to make the light and dark shadows in each area.

**4.** Go back over the parts that need to be darkened, and then apply a little graphite outside the drawing to locate it in the space that surrounds it.

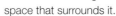
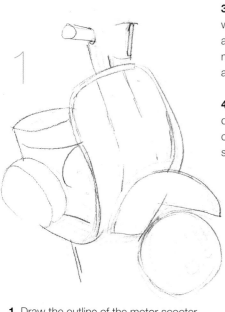

**1.** Draw the outline of the motor scooter with a hard pencil to make a light and precise line that will not get in the way of the shading done with the stick of graphite.

**2.** Use one of the short edges to apply a stroke with straight edges to cover the middle part of the shell of the motor scooter.

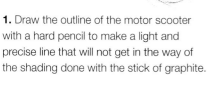

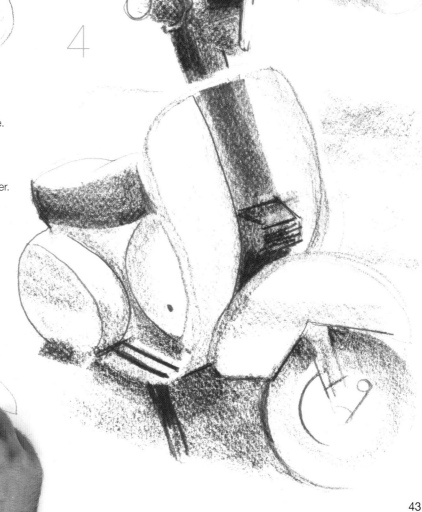

**LEVEL OF DIFFICULTY**
★ ★
**TOOLS**
HB and 6B Graphite Pencils
**SUPPORT**
80 lb (180 gr) Lightly Textured Paper

**When you draw with soft and very soft pencils, you can create strokes with interesting variations and intensities that become gradations. These gradations suggest shadows and their progressive movement toward light. This intricate drawing almost entirely consists of gradations made with a very soft pencil.**

**1.** Make a basic sketch of the motor with an HB pencil, using very light strokes so they will not be visible in the final drawing.

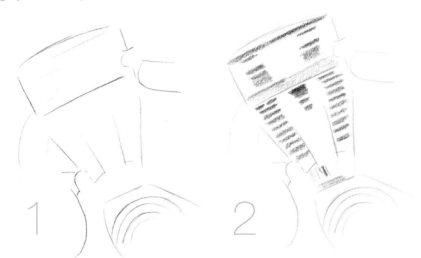

**2.** Make a series of parallel strokes that correspond to the darkest bands of the motor. Draw them with decreasing intensity to create a gradation in each one of the marks.

**3.** When you make the marks, hold the pencil at a low angle to the paper so the point will create wide lines. Move it with zigzag motions as you work your way down.

If you use pencils with hard leads in drawings mainly created with soft pencils, the lines will nearly be invisible. Here, using an HB pencil, mark the direction that the vertical gradations should follow; the marks will barely be seen in the final drawing.

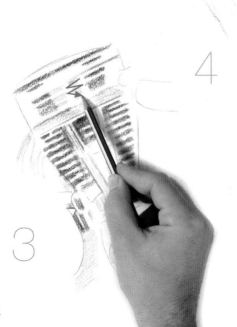

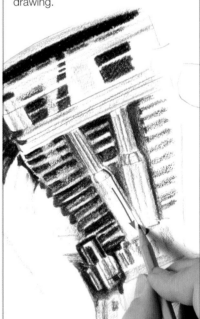

**4.** The group of gradated strokes already looks like the completed structure of a motor. From here on the process will consist of creating relief on each part by darkening the gradations.

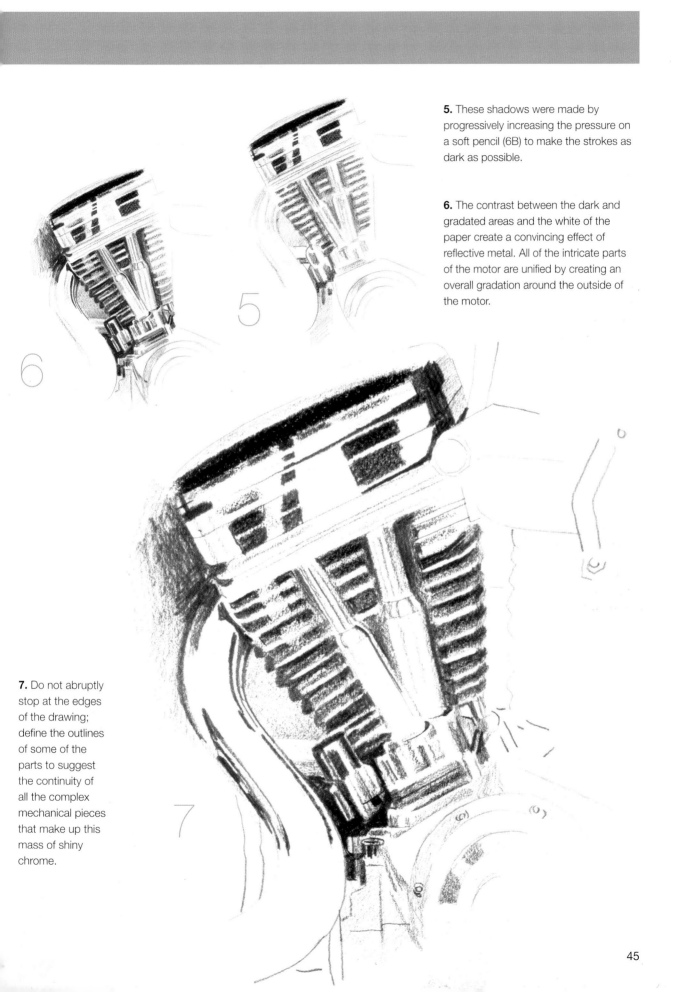

**5.** These shadows were made by progressively increasing the pressure on a soft pencil (6B) to make the strokes as dark as possible.

**6.** The contrast between the dark and gradated areas and the white of the paper create a convincing effect of reflective metal. All of the intricate parts of the motor are unified by creating an overall gradation around the outside of the motor.

**7.** Do not abruptly stop at the edges of the drawing; define the outlines of some of the parts to suggest the continuity of all the complex mechanical pieces that make up this mass of shiny chrome.

**LEVEL OF DIFFICULTY**
★
**TOOLS**
HB Graphite Pencil
Graphite Powder
**SUPPORT**
80 lb (180 gr) Lightly Textured Paper

Powdered graphite can only be used for drawing if you rub it to spread it over the paper with a brush, a rag, or your fingertips. In this exercise, you will be using your fingertips. The subject is the transparency created by a grouping of bottles. The method does not allow you to be precise in either the drawing or the shading, but it creates a unique atmospheric tone.

**1.** You do not want to see any lines in this drawing; therefore, the lines used for blocking in should be very minimal and light, drawn with a hard lead (HB).

**2.** The procedure is very simple: dip the tip of your finger in graphite powder and "draw" with it. The "lines" will be thick and have very blurry edges. After they are drawn, color the main part of the bottle with the rest of the graphite that is still on your finger.

**3.** The difficulty of accurately controlling the shading and gradations can become an advantage if you spread the graphite powder in multiple gradations on the glass containers.

**4.** The drawing will have a certain form and definition. They will result from your repeated work on the dark edges of each bottle with your finger and a lot of graphite, until you create lines with a more or less consistent width.

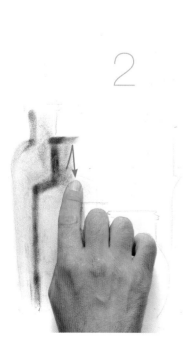

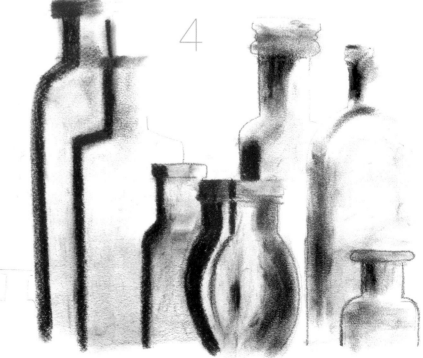

**LEVEL OF DIFFICULTY**
★
**TOOLS**
HB and 4B Graphite Pencils
Blending Stick
**SUPPORT**
80 lb (180 gr) Lightly Textured Paper

Blending sticks are generally used to gradate shading made with charcoal, but they can also be used with graphite drawings. The big difference is that you cannot just use the blending stick directly on the drawing to blend the lines; it first must be dipped in graphite before applying it to the paper.

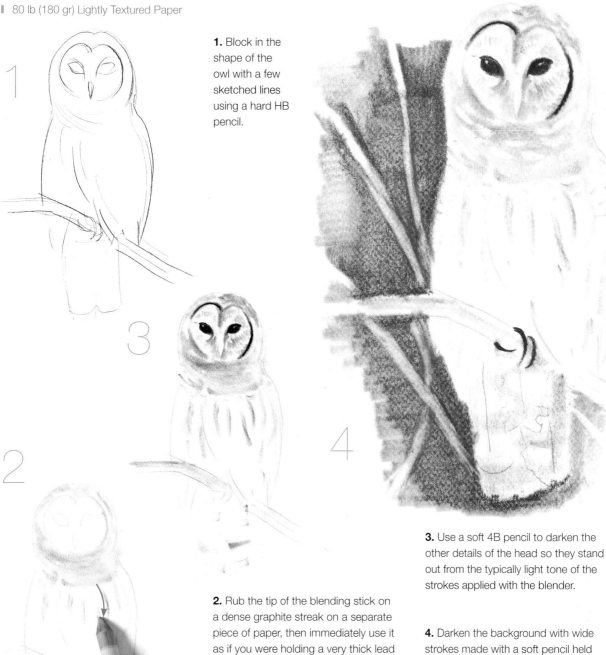

**1.** Block in the shape of the owl with a few sketched lines using a hard HB pencil.

**2.** Rub the tip of the blending stick on a dense graphite streak on a separate piece of paper, then immediately use it as if you were holding a very thick lead for indicating the plumage of the bird. Make a few wide strokes around the head and on the body.

**3.** Use a soft 4B pencil to darken the other details of the head so they stand out from the typically light tone of the strokes applied with the blender.

**4.** Darken the background with wide strokes made with a soft pencil held nearly flat on the paper. The large, dark shaded area emphasizes the outlines of the bird and reveals the soft tones of its plumage.

**LEVEL OF DIFFICULTY**
★ ★

**TOOLS**
HB, 2B, and 4B Graphite Pencils
6B Graphite Stick

**SUPPORT**
90 lb (200 gr) Lightly Textured Paper

This exercise combines different techniques in a single drawing. It is the representation of an old boat that uses all the graphic approaches typical of a graphite pencil. The goal is to create the texture of the old boards, capturing the light and shadow that indicate the relief and wide volume of the vessel.

**1.** Draw a sketch of the boat with an HB pencil. Using the hardest pencil will help you avoid making dark lines.

**2.** Use the 2B pencil to begin defining the wood slats that the boat is made of, making small vertical and horizontal lines that suggest the texture.

**3.** Continue with the 4B pencil. Now create the texture of the rail with short, slightly curved vertical marks to suggest the rounded form of this part.

**4.** Combine the textural marks with some hatch lines for shading. These should be simple perpendicular hatch lines that darken the left side of the belly of the boat.

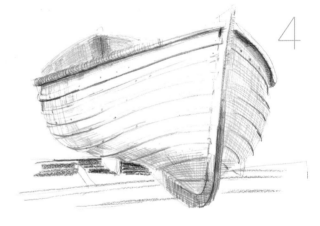

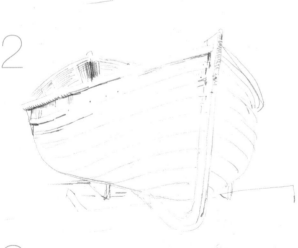

Extra thick graphite sticks are available in several grades of hardness. The softest of all (6B) makes a very dark and dense stroke, as you can see in the lines drawn in the shaded part of the rear of the boat.

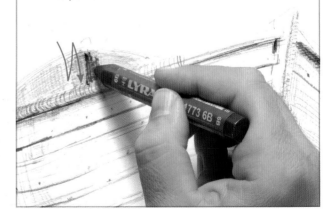

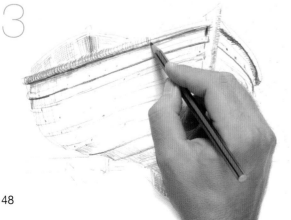

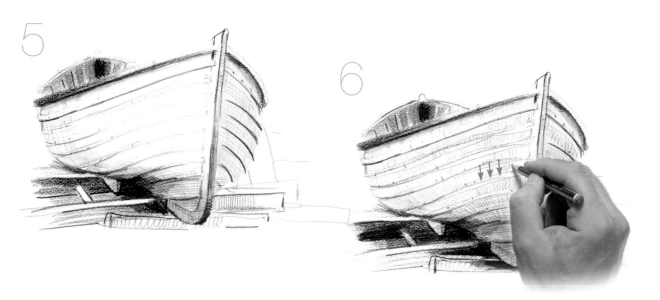

**5.** Shade the darkest parts of the drawing with the graphite stick, covering the lines with much darker lines.

**6.** Improve the texture of the boards of the vessel with a 2B pencil, using vertical lines that are not too close together; this way you avoid creating new shading in areas that are in light.

**7.** Here is a balanced and convincing whole created with hatching and shading, enriched with dense strokes of soft graphite and marks of texture that create rich and subtle results.

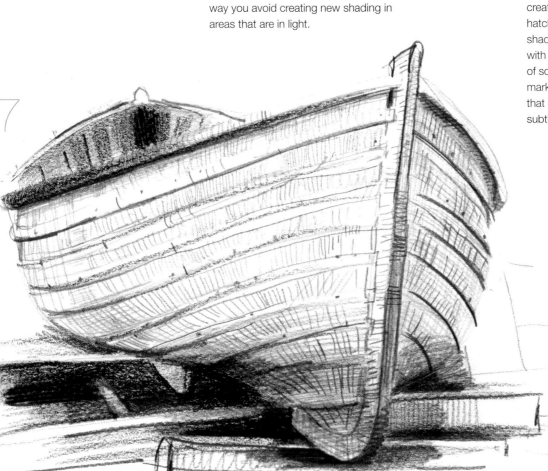

**LEVEL OF DIFFICULTY**

★

**TOOLS**

2B Graphite Pencil
Graphite Powder
Bristle Brush

**SUPPORT**

80 lb. (180 gr) Medium Textured Paper

**Powdered graphite can also be spread with a stiff brush (bristle brush), similar to the way that paint is applied to a support. The lines or strokes will be diffused and create interesting shading on a drawing. It can then be complemented with lines made with a conventional pencil.**

**1.** Begin with a simple triangular sketch that can be complemented with a few lines that define the volume of a hen and the position of its legs.

**2.** Shade the lower part of the bird with a brush and graphite powder. Rub the bristles vigorously on the paper so the powder will adhere well to the surface.

**3.** Use a graphite pencil to suggest the feathers with simple angular marks, and include the details of the head and the feet.

**4.** The combination of blended shadows and pencil lines creates a drawing in which the shaded volume of the body of the hen is modeled and detailed with the linear marks.

**LEVEL OF DIFFICULTY**

★

**TOOLS**

Wood or Plastic Stylus
6B Graphite Stick

**SUPPORT**

90 lb (200 gr) Medium Textured Paper

In this drawing, you will use an empty ballpoint pen to engrave the surface of the paper before shading it. However, this tool can be replaced by any other with a point that is not too sharp. The shading causes the marks of the pen to show up as fine white lines.

**1.** Draw the plant with the point of the graphite stick to make a homogenous solid line. Do not add more details other than shading the surface of the paper.

**2.** Engrave the paper with parallel lines, longer ones on the petals and short on the stems. Then add a few details in the corollas.

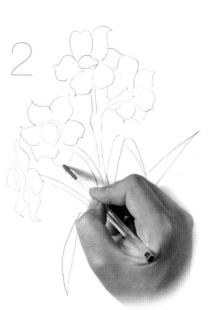

**3.** The lines engraved in the paper will become visible when you carefully rub the flat graphite stick over them.

**4.** This process is very simple, but the results are very rich and look like they take much more effort than they do. The engraved lines will suggest more subtle shading than you will actually apply.

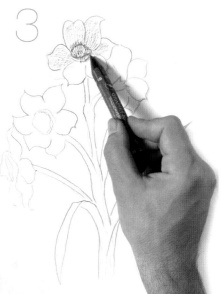

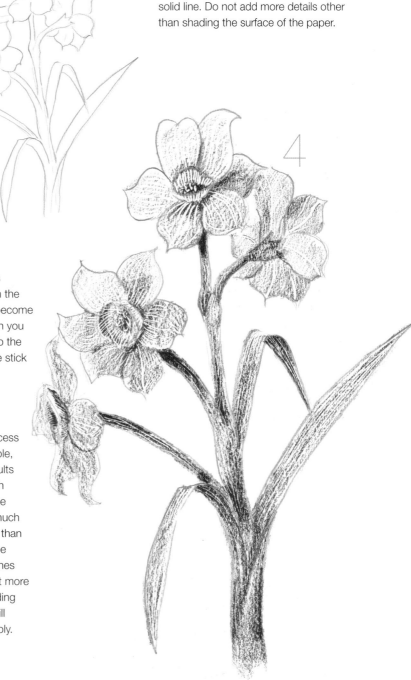

**LEVEL OF DIFFICULTY**

★ ★

**TOOLS**

4B Water-Soluble Graphite Pencil

Round Natural Hair Watercolor Brush

**SUPPORT**

120 lb (250 gr) Heavy Textured Paper

Water-soluble graphite is a variety that can be dissolved in water and can be spread and worked with a brush. You use it in the same way as any other pencil, and the tone and intensity are the same. They are available with leads of different hardness. Here you will use a soft lead because it leaves a greater amount of graphite on the paper, which will make a darker tone when it is wet.

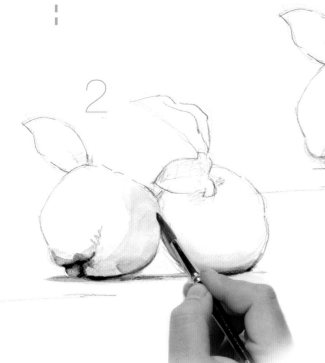

**1.** The initial sketch should be simple, and you will continue going over the lines as you work so that later there will be graphite to work with.

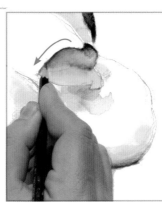

Water-soluble pencils can also be used by dipping the point in water. This approach will create a much darker line because the lead dissolves when it is applied to the paper. This can be a good alternative to dampening the paper.

**2.** Pass a wet brush over the drawing, which will cause the lines to dissolve and the water to turn a gray tone that you can use to create transparent shadows.

**3.** The darkest accents, on the undersides of the fruit and in some details on the leaves, can be added by going over the areas while they are still damp from the effects of the brush.

**4.** Here you can see how it is possible to create dark details by working on damp paper: the line spreads slightly because of the dampness, which also increases its intensity.

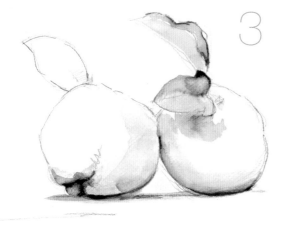

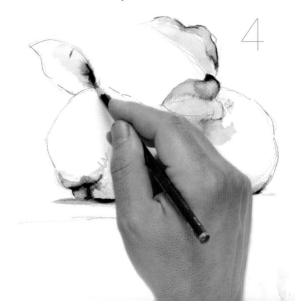

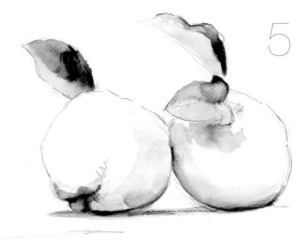

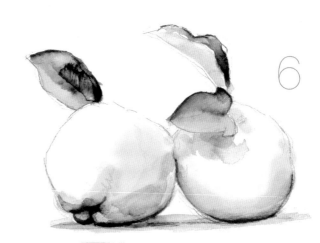

**5.** Create the darkest areas by working on them after the paper has been dampened with a wet brush. These dark contrasts are necessary to emphasize the clarity of the illuminated parts.

**6.** The shading on the main part of the fruit is a very pale tone, which you can create using light pencil lines.

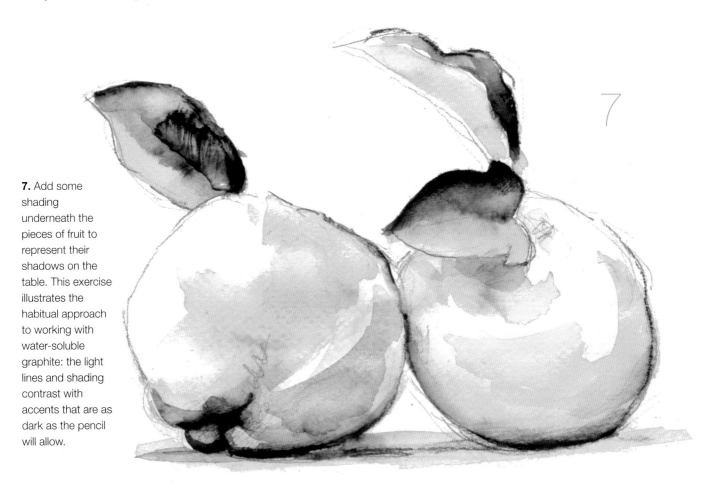

**7.** Add some shading underneath the pieces of fruit to represent their shadows on the table. This exercise illustrates the habitual approach to working with water-soluble graphite: the light lines and shading contrast with accents that are as dark as the pencil will allow.

**LEVEL OF DIFFICULTY**

★

**TOOLS**

Natural Charcoal Stick

**SUPPORT**

90 lb (200 gr) Medium Textured Paper

**Charcoal sticks, when used without blending the lines and shading, produce a very limited range of different tones: the grayish black of a direct and solid stroke and the lighter effect created by lightly rubbing the stick on the paper. This drawing will be done using these two techniques.**

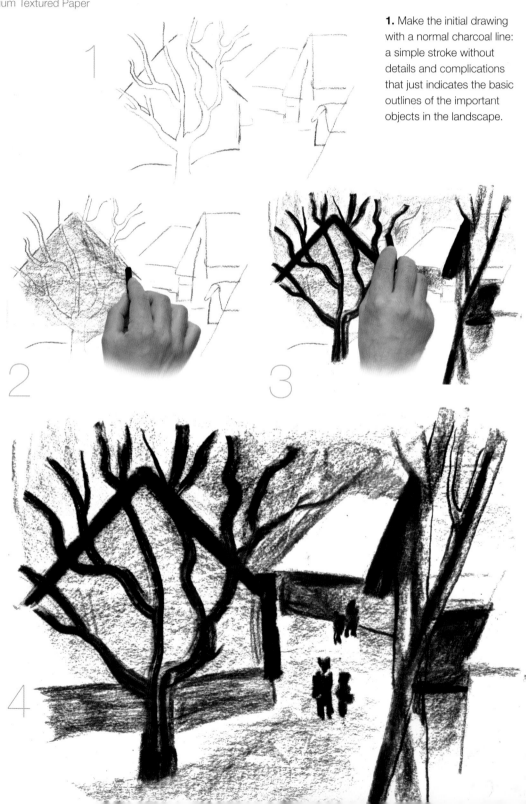

**1.** Make the initial drawing with a normal charcoal line: a simple stroke without details and complications that just indicates the basic outlines of the important objects in the landscape.

**2.** By rubbing the side of the charcoal on the paper you will obtain a gray tone resulting from small streaks of charcoal and white areas left by irregularities of the stick and the paper.

**3.** Rubbing harder with the point of the stick creates some black (or nearly black) tones that, in this case, will define the branches of the tree and create a dark silhouette with no tonal variations.

**4.** Alternate black lines with gray ones. The variations of gray result from overlaying charcoal lines lightly rubbed on the paper.

**LEVEL OF DIFFICULTY**
★

**TOOLS**
2B Graphite Pencil
Natural Charcoal Stick

**SUPPORT**
90 lb (200 gr) Medium Textured Paper

**Strokes made with charcoal have an irregular tone and imprecise edges, but they can be used to draw the shape of an animal in an Impressionist style with an informal combination of line and shadow. The representation of this cat is direct and characterized by a clear economy of means.**

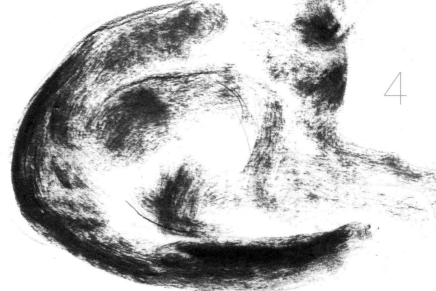

**1.** The pencil drawing should be rather rough so the role of protagonist can be left to the charcoal.

**2.** Apply the side of the charcoal stick to the paper, drawing in those places that indicate the shape of the animal: the back, the tail, the ears, and the nose.

**4.** The eyes and the nose require careful drawing, but both are created the same way with the point of the charcoal stick, changing the pressure to create lighter and darker tones.

**3.** The differences in tone result from the different amounts of pressure you apply to the stick: it will be more intense on the ears, the back, and the tail and lighter on the inside of the drawing.

**LEVEL OF DIFFICULTY**
★

**TOOLS**
Natural Charcoal Stick
Compressed Charcoal Stick

**SUPPORT**
90 lb (200 gr) Medium Textured Paper

Compressed charcoal makes a much darker black tone than natural charcoal and, therefore, increases charcoal's limited tonal range. In this exercise, you will be able to see the contrast between the tones made with natural charcoal and the deep shadows that can be made with compressed charcoal.

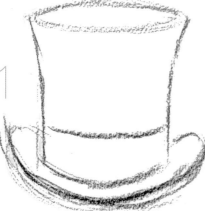

**1.** The drawing of the subject should be extremely simple; sketch in a few outlines with natural charcoal without applying very much pressure to it.

**2.** Cover the hat with an overall tone using your fingertips, and reinforce the tone in the middle part of the hat.

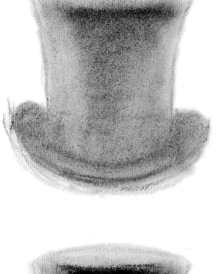

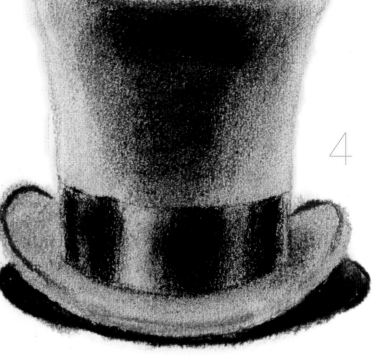

**3.** Add the vertical bands using compressed charcoal; you will see the intensity of the black made by this stick compared to the gray of the natural charcoal.

**4.** To finish the drawing, darken the area beneath the hat with strokes of natural charcoal and do not rub them. The compressed charcoal creates a contrasting texture on the surface of the shiny hatband.

**LEVEL OF DIFFICULTY**
★
**TOOLS**
Natural Charcoal Stick
Compressed Charcoal Stick
**SUPPORT**
90 lb (200 gr) Medium Textured Paper

The intensity of the black made with the compressed charcoal can be seen where it is in contrast to the light shading made with natural charcoal that suggests the modeling of the objects in this exercise. Its density and feeling of solidity is particularly useful in this chiaroscuro drawing.

**1.** Draw the objects very lightly on the paper with the natural charcoal so the lights will be as faint as possible. When you have created their approximate shapes, go around their basic outlines with darker lines.

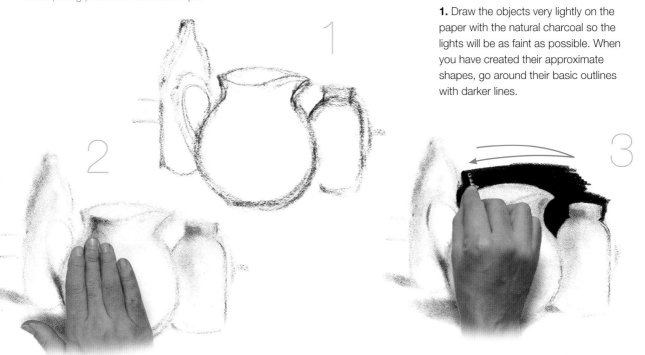

**2.** Blend the drawing with your fingertips to create an even tone without any dark accents.

**3.** Use the compressed charcoal stick to darken around the objects with very dark hatch lines. Then blend the lines with your fingertips to create a uniform black tone.

**4.** The objects are clearly silhouetted against the black; their modeling now looks very light and suggests intense light in front of a very dark background, which is typical of chiaroscuro drawings.

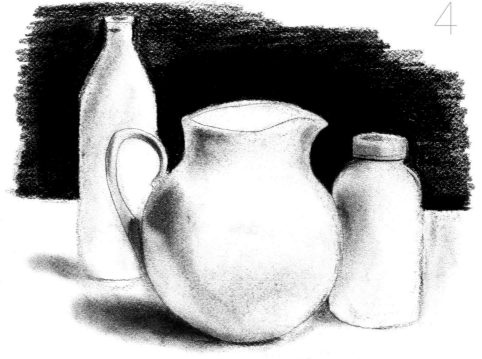

**LEVEL OF DIFFICULTY**

★ ★

**TOOLS**

Natural Charcoal Stick

Charcoal Pencil

**SUPPORT**

90 lb (200 gr) Medium Textured Paper

**Line work and blended shading are nearly opposite techniques: while lines define and limit, shading unifies by removing the edges of shapes. If they are used together they can complement each other well by simultaneously showing shapes and details as well as the shading of the whole image.**

1

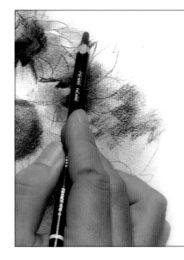

**1.** Apply a shapeless mass of charcoal and then draw some lines over it to indicate the locations of the flowers.

The charcoal pencil can be used to draw fine light lines and also thick dark ones that are nearly black. These strokes and lines cannot be blended very well, so it is a good idea to use charcoal pencils in combination with natural charcoal.

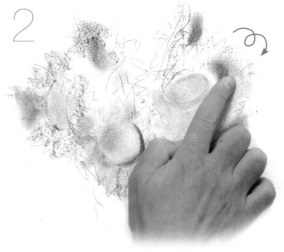

2

**2.** Use your fingertip to rub the centers of the flowers that you have previously drawn to create focal points for developing the drawing.

**3.** Use a charcoal pencil to darken the area around the petals of the flowers in the foreground so they will stand out from the charcoal shading.

**4.** The blurry tone that you spread at the beginning of the exercise is now the color of the flowers themselves, contrasting with the dark areas wherever it is necessary to emphasize the important details.

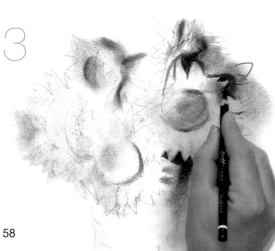

3

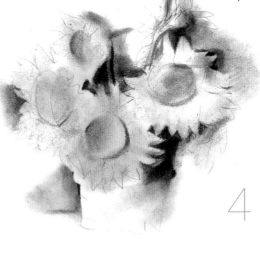

4

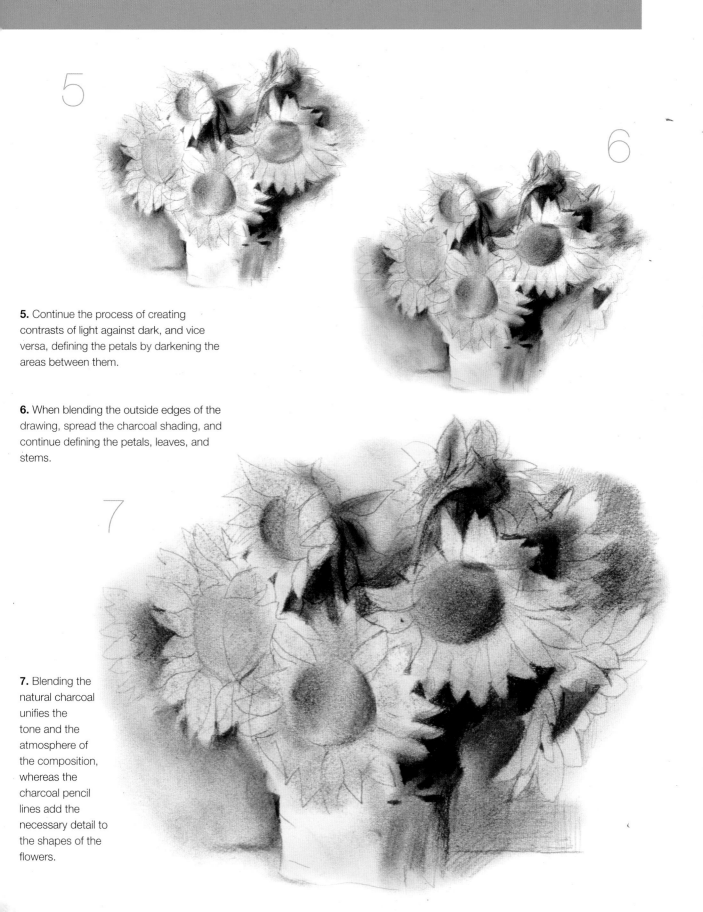

**5.** Continue the process of creating contrasts of light against dark, and vice versa, defining the petals by darkening the areas between them.

**6.** When blending the outside edges of the drawing, spread the charcoal shading, and continue defining the petals, leaves, and stems.

**7.** Blending the natural charcoal unifies the tone and the atmosphere of the composition, whereas the charcoal pencil lines add the necessary detail to the shapes of the flowers.

**LEVEL OF DIFFICULTY**
★
**TOOLS**
Natural Charcoal Stick
Compressed Charcoal Stick
**SUPPORT**
90 lb (180 gr) Cool Gray Laid Paper

**Papers of various colors other than white are frequently used for making drawings with charcoal, especially when white chalk is used. This is a hard pastel stick used to highlight the lighter tones on subjects drawn with charcoal, but only when the paper is not white.**

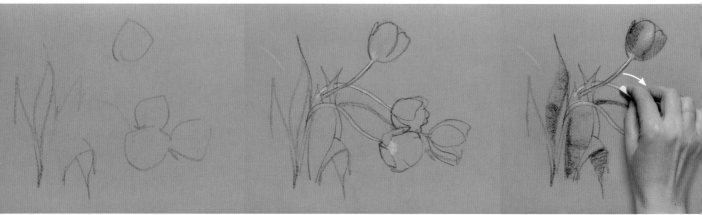

**1.** Draw some outlines of the leaves and shapes of the flowers without defining the stems yet. The compressed charcoal will define these lines more accurately than natural charcoal.

**2.** Complete the linear design of the exercise by adding the stems and outlines of the petals of the tulips.

**3.** Shade the flowers with several applications of charcoal, then hold the stick of white chalk flat on the paper to highlight some of the stems.

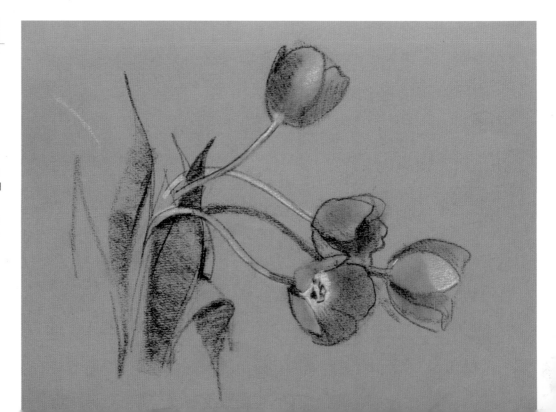

**4.** There is no blending in this drawing; all of the shading is created by dragging the sides of the sticks on the paper. The white highlights contrast strongly against the cool gray tone of the color paper.

**LEVEL OF DIFFICULTY**
★

**TOOLS**
Natural Charcoal Stick
Hard Gray Pastel Stick

**SUPPORT**
90 lb (200 gr) Medium Textured Paper

Natural charcoal and pastel sticks are very similar: both can be blended easily and, to a certain point, even mixed with each other to create intermediate tones. In this exercise, you will use them to create an interesting shiny effect based on tonal contrast.

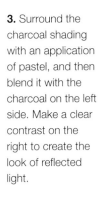

**1.** Draw a sketch of the shoe with a charcoal stick. You should only be interested in blocking in the approximate shape of the object with quick sketchy lines.

**2.** Draw an S shape with the side of the charcoal stick on the middle of the shoe. This shading will represent the darkest area of the entire drawing.

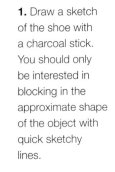

**3.** Surround the charcoal shading with an application of pastel, and then blend it with the charcoal on the left side. Make a clear contrast on the right to create the look of reflected light.

**4.** The blending process creates an interesting effect of contrast. You can see how the charcoal and the pastel do not mix completely but that the two create a gradation with each other.

**5.** Finally, make lines, alternating the charcoal and the pastel, to indicate the laces and the seams on the surface of the shoe.

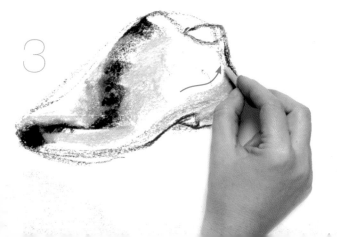

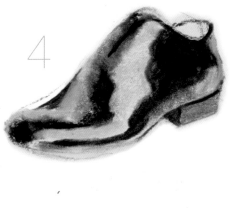

**LEVEL OF DIFFICULTY**
★
**TOOLS**
Water-Soluble Charcoal Pencil
Natural Hair Watercolor Brush
**SUPPORT**
90 lb (200 gr) Medium Textured Paper

There are water-soluble versions of charcoal pencils, although they are less well known than water-soluble graphite pencils. They look like normal charcoal pencils, but their lines can be diluted and spread with a wet paintbrush.

**1.** Draw this figure with the charcoal pencil without applying much pressure to the paper. You want to make light lines that can be diluted to create dark washes.

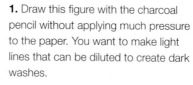

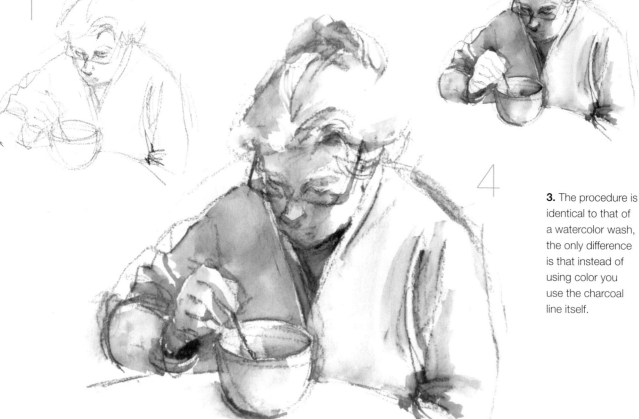

**3.** The procedure is identical to that of a watercolor wash, the only difference is that instead of using color you use the charcoal line itself.

**2.** Passing a wet brush over the lines will dilute them and cause them to make a light gray layer of color on the surface of the drawing.

**4.** After all the surfaces have been lightly washed, this delicate drawing can be considered finished. Its tonality owes as much to the transparency of the wash as to the tone of the charcoal itself.

**LEVEL OF DIFFICULTY**
★
**TOOLS**
Natural Charcoal Stick
Rubber Eraser
**SUPPORT**
90 lb (200 gr) Medium Textured Paper

**Charcoal can be very easily erased, and this allows the artist to use the eraser as an alternative drawing tool. As you will see in this exercise, you can use the eraser to make a simple line or a group of lines that will stand out as white against the black of the charcoal shading.**

**1.** First spread charcoal shading on the paper blended with your fingertips. This shading is what will allow your erased lines to be seen.

**2.** Draw simple outlines of the bananas with the point of the charcoal, and then make lines with the eraser as if it were a drawing tool.

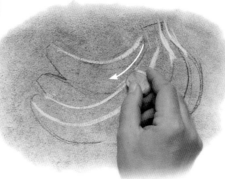

**3.** Completely erase the charcoal on the most brightly lit sides of the bananas. These sides are limited by edges or corners so you do not have to gradate the tones with the rest of the shading.

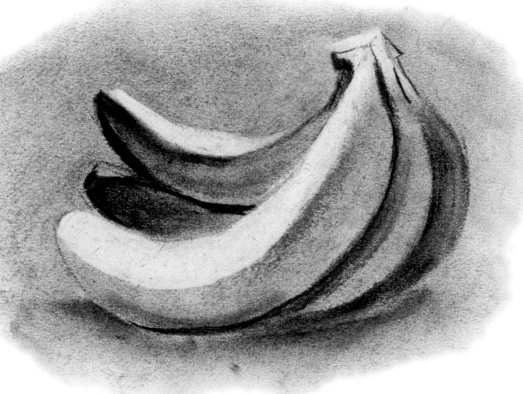

**4.** To finish, darken the tones of the charcoal in the most shaded areas; this will make the white areas stand out more and make the bunch of bananas look very realistic.

TOOLS
Natural Charcoal Stick
Blending Stick
Rubber Eraser
SUPPORT
90 lb (200 gr) Medium Textured Paper

A blending stick is a cylinder of spongy rolled paper; it has a conical point on each end and is used for blending charcoal strokes by rubbing them into the paper with the point. In this drawing, you will use the blender not only for blending and reducing the intensity of the lines but also for drawing and covering some areas with light tones.

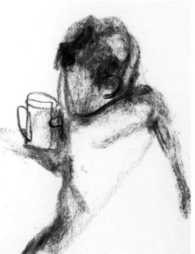

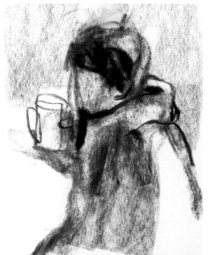

**1.** Draw this figure of a child drinking from a glass. The initial drawing is a quick spontaneous sketch that combines lines in some detailed areas with shading on different parts of the figure.

**2.** Continue to darken certain areas and add accents drawn with heavy lines, like the scarf. It is helpful to build up the charcoal in the drawing so you can later spread it with the blending stick.

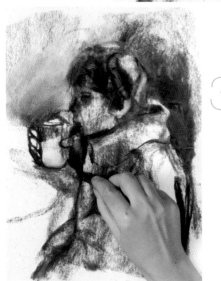

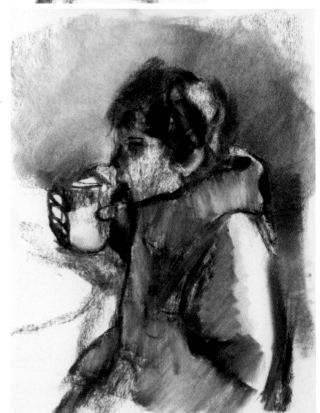

**3.** The drawing will become increasingly denser with repeated applications of charcoal. Leave some areas white, where the light is the brightest.

**4.** Rub the shading on the sweater with the blending stick: the lightest lines made by rubbing with the blender look like marks made with a paintbrush.

**5.** Rub nearly the entire drawing with the blending stick. The mark of the tool looks a lot like a brush stroke; use it to model the volumes and to develop the areas of shadow against the most well-lit areas.

**6.** Create the white of the milk in the glass by removing the charcoal with an eraser. (This technique will be further developed in later exercises in this section.) Blend the upper part of the glass by rubbing vertically to suggest the texture of the glass material.

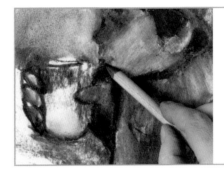

You cannot draw with the blending stick itself; you can only spread material that is already there. Irregular charcoal lines are turned into a more or less homogenous gray-toned surface by rubbing them with the blender.

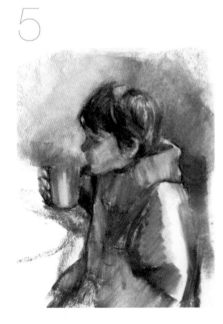

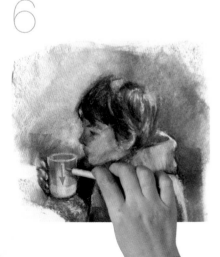

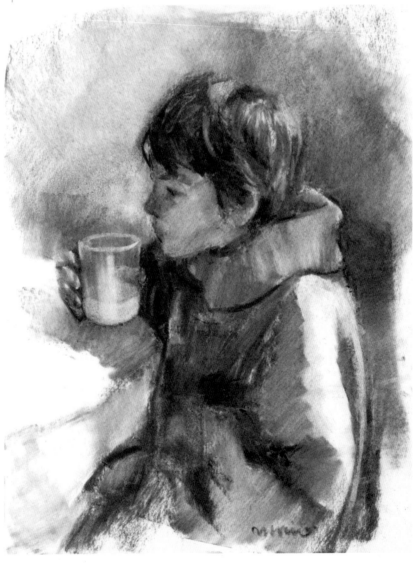

**7.** The blending stick allows you to model the drawing with much more precision than with your fingers. The point can be used to add details, while the side of the tip can be used for wider, more general lines.

**LEVEL OF DIFFICULTY**
★ ★
**TOOLS**
Charcoal Pencil
Sanguine Pencil
White Chalk Pencil
**SUPPORT**
90 lb (200 gr) Medium Textured
Gray Paper

In reality, both sanguine and white chalk are varieties of pastel. They are much harder than the corresponding red oxide and white pastels. You will learn to use them here, outside of the context of the section dedicated to pastels, because the combination of the three colors (black, red, and white), on a non-white background, is a richer version of the traditional charcoal drawing.

**1.** The light and warm color of the background makes the white stand out and harmonizes with the other colors. This harmony of the lines and the background can be seen from the beginning: the initial drawing is just a few sketched lines that are emphasized by the color of the paper.

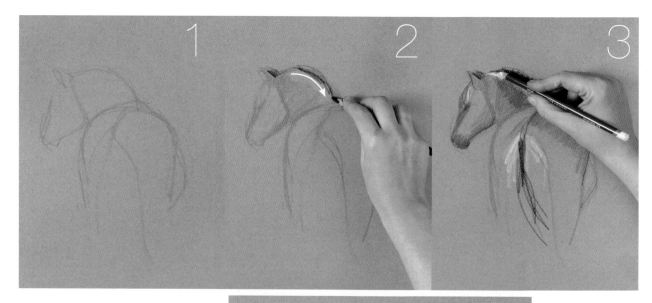

**2.** Marks made by the charcoal and chalk pencils can be overlaid without difficulty, and the intensity of their lines is the same. Overlaying the lines would not work as well if you were using natural charcoal, which makes a heavier line but with a lighter tone.

**3.** The overlaying of colors progresses as the drawing progresses. Now it is time to highlight the white lines, which are clearly visible on the gray tone of the paper.

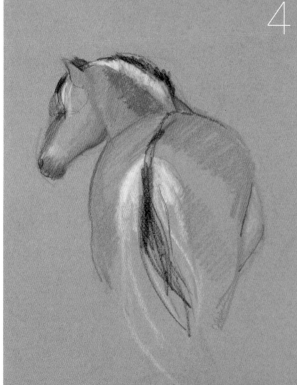

**4.** Model the body concisely with wide lines of sanguine. Reserve the white to emphasize some areas of the mane and tail, and use the charcoal pencil to shade the same details, adding the necessary black accents to this simple but effective drawing in three colors.

**LEVEL OF DIFFICULTY**

★

**TOOLS**

Charcoal Pencil

White Chalk Pencil

**SUPPORT**

90 lb (200 gr) Medium Textured
Blue Paper

The intensity of the color of the support can be an advantage for your drawing. A background with a saturated and intense color like the one you will use for this drawing will not only complement the subject, since the color of the paper is that of the sky, but will make the white chalk lines stand out.

**1.** Draw the outline of the seagull with the white chalk pencil. The intense blue color of the paper contrasts strongly with the white lines.

**2.** Shade the seagull with the charcoal pencil, and then add light white lines to the drawing to create a gradated gray tone that is darker at the edges than in the center of the bird.

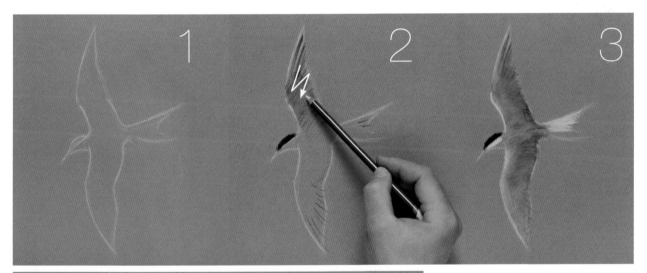

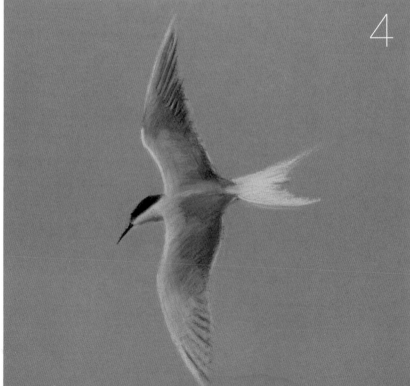

**3.** In this image, you can see how the gray tone on the wings was made by combining the black and white lines.

**4.** Finally, go over the outlines and create a gradation from them to the darkest areas on the inside of the bird.

**LEVEL OF DIFFICULTY**
★ ★

**TOOLS**
Charcoal Pencil
Sanguine Pencil
White Chalk Pencil

**SUPPORT**
90 lb (200 gr) Medium Textured
Light Brown Paper

Portraits in three colors are a traditional technique used for drawings that was very popular during the 18th and 19th centuries. The technique consists of using charcoal, sanguine, and white chalk pencils on a support with a warm or cool tone, and that is any color but white, so that the white highlights can easily been seen.

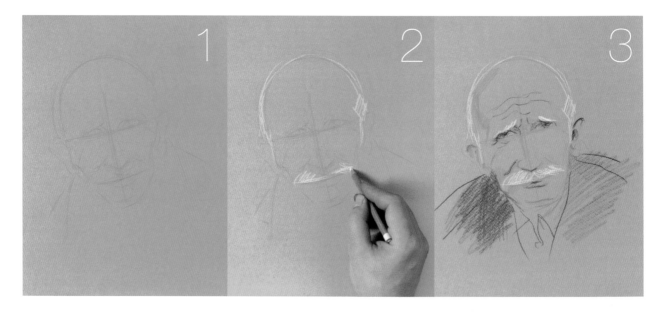

**1.** Draw the model's head and locate the facial features within it, blocking them in with the sanguine pencil. Blocking in consists of a vertical line drawn in the center of the head and another perpendicular line at the height of the eyes.

**2.** Use the white chalk pencil to create the general tone of the moustache and hair. Do not worry about making your lines perfect because this drawing is meant to be more of a sketch than a fully finished portrait.

**3.** Alternate the use of the black and sanguine pencils to shade the shoulders and also to go over the lines of the forehead, the eyes, and the lips. Some lightly drawn sanguine hatch lines can be used to create some shading.

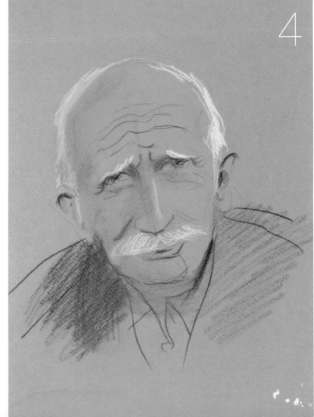

**4.** To finish the drawing just blend the previously added hatch lines with your fingertip.

**LEVEL OF DIFFICULTY**
★
**TOOLS**
Water-Soluble Charcoal Pencil
Round Watercolor Brush
**SUPPORT**
120 lb (250 gr) Medium Textured Paper

Water-soluble charcoal is not a widely used drawing medium. The pencils are quite soft and make a dark line, a line that can be diluted with a wet paintbrush to create gradations and shading, just as you will be doing in this exercise.

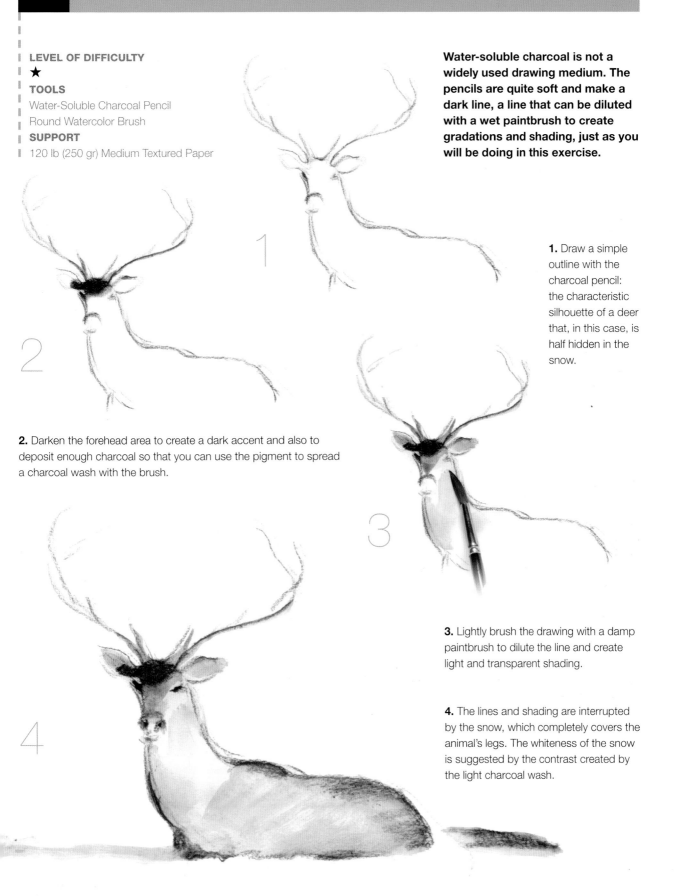

**1.** Draw a simple outline with the charcoal pencil: the characteristic silhouette of a deer that, in this case, is half hidden in the snow.

**2.** Darken the forehead area to create a dark accent and also to deposit enough charcoal so that you can use the pigment to spread a charcoal wash with the brush.

**3.** Lightly brush the drawing with a damp paintbrush to dilute the line and create light and transparent shading.

**4.** The lines and shading are interrupted by the snow, which completely covers the animal's legs. The whiteness of the snow is suggested by the contrast created by the light charcoal wash.

**LEVEL OF DIFFICULTY**
★ ★

**TOOLS**
Natural Charcoal Stick
Cotton Rag

**SUPPORT**
90 lb (200 gr) Medium Textured Paper

A charcoal drawing can be reduced to shadows that barely require any details. This is a very simple and stylized approach to drawing with charcoal. Start with very generic shading, and apply only the most necessary highlights to achieve a figurative effect.

**1.** Darken the paper by applying the side of a stick of charcoal on the paper. The stroke should suggest the shape of the head and neck of a horse.

**2.** Erase the charcoal with a rag so that only a very faint indication is left on the paper. This mark will be enough for you to build up the final drawing.

**3.** Always use the side of the charcoal stick. Shade the anatomical form of the animal, emphasizing the darkest parts like the mane and the ear.

**4.** Darken the neck to create a contrast against the rest of the body, suggesting the effect of relief or depth. This is enough for you to consider the drawing finished.

**LEVEL OF DIFFICULTY**
★
**TOOLS**
Charcoal Pencil
**SUPPORT**
90 lb (200 gr) Medium Textured
Paper

Charcoal pencils and compressed charcoal can be used to make very dark and saturated blacks. The black color can then be blended or reduced to harmonize the tones in the drawing, but it is also possible to create interesting effects based on strong black-white contrasts like those you will create in this exercise.

**1.** Begin by lightly sketching the basic outline of this zebra. Do not apply much pressure to the paper with the charcoal so the lines will barely be visible.

**2.** After making an acceptable likeness, begin drawing lines that correspond to the stripes on the zebra. Apply pressure when drawing them; the lines should now be dark.

**3.** Increasing the pressure with the pencil point creates dense blacks that strongly contrast with the white of the paper.

**4.** Draw the mane and go over some of the stripes. Finally, you can add some shading on the underside of the zebra's neck.

**LEVEL OF DIFFICULTY**
★ ★

**TOOLS**

Natural Charcoal Stick
Charcoal Pencil
Sanguine Stick
Sanguine Pencil
White Chalk Stick

**SUPPORT**

90 lb (200 gr) Medium Textured Paper

It is always helpful when some aspect of the subject matter coincides with some aspect of the medium being used. In this case, the rust that covers the body of this old car in a junkyard is the same red oxide color as the sanguine pencil or stick. You will see how you can take advantage of these circumstances in this exercise.

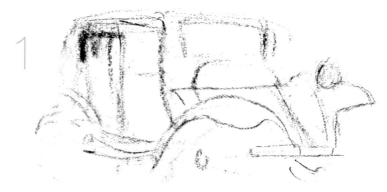

**1.** Make this drawing with a piece of charcoal. Do not spend too much time on it, but allow the lines to wander a bit as if you were doodling.

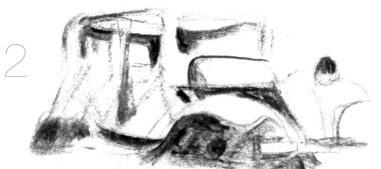

**2.** Darken the areas that could be in shadow. Mark them with the point of the charcoal to create an initial indication of relief.

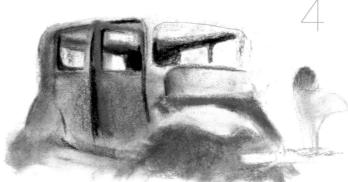

**3.** Use the sanguine stick to color in red highlights on some of the edges of the vehicle.

**4.** Using your fingertip, rub the entire drawing to blend the charcoal tones with the sanguine to create a general color that will be the base for additional shading.

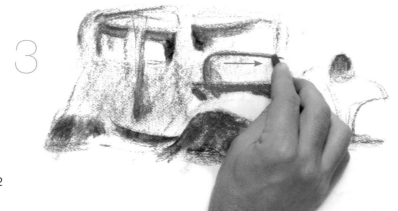
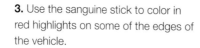

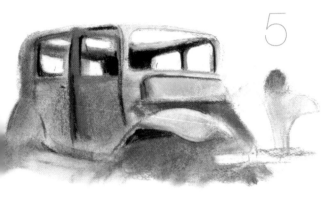

5

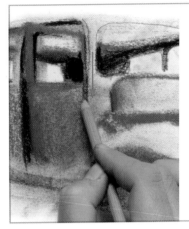

Now you can use the sanguine pencil to draw the lines that look like edges in clear contrast against the charcoal. The sanguine pencil can be sharpened and used to draw very accurate shapes.

**5.** Apply new highlights on the edges of the doors and the sides of the frame, this time using the charcoal pencil instead of the natural charcoal stick. Continue using the sanguine stick.

**6.** Use the white chalk stick to unify and lighten the areas that are most brightly lit. After each application blend the retouched area with your fingertip.

**7.** In the finished drawing, you can see how the sanguine color is quite close to the typical color of rust. The realistic effect is simple and efficient.

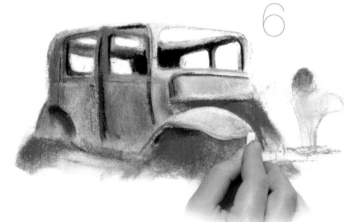

6

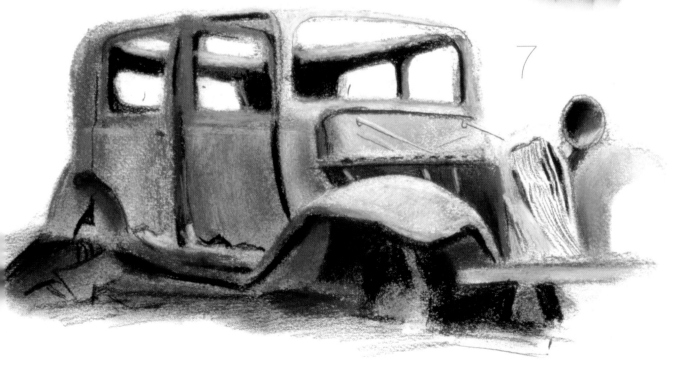

7

**LEVEL OF DIFFICULTY**
★ ★

**TOOLS**
Natural Charcoal Stick
Kneaded Eraser

**SUPPORT**
90 lb (200 gr) Medium Textured Paper

**The kneaded eraser has its origins in the bread used in the old days by artists to modify their charcoal drawings. This tool is used to lighten dark areas to create accents and highlights that vary the shading of charcoal drawings.**

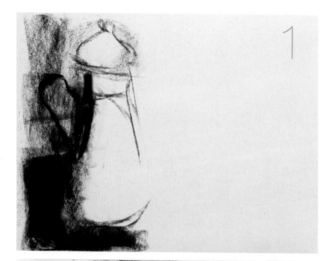

**1.** Begin with a direct approach, applying the drawing and shading at the same time, which means coloring the paper while you are also drawing the outlines.

**2.** Use the shading to try to create the form of the container that appears behind the coffee pot before defining the drawing, by dragging the side of the stick on the paper. This approach to the drawing allows you to construct the light, shadow, and outlines simultaneously.

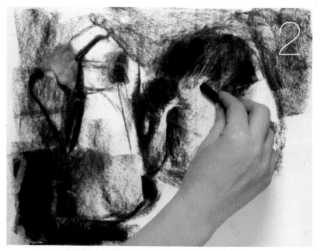

**3.** The objects are masses of light and shadow, and the latter consist of a hodgepodge of charcoal shading. For now, the entire drawing is somewhat chaotic, but it will be defined little by little.

**4.** Use your finger to blend, creating intermediate tones and areas of light and shadow by means of other areas of transition.

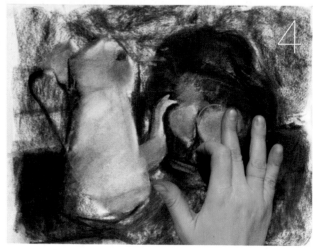

**5.** The blended areas will allow you to more clearly see the placement of the objects in the drawing and the contrasts between the basic planes of light and those of shadow.

Lightly rubbing with a kneaded eraser will allow you to lighten dark areas because the particles of charcoal adhere to it. It is the best tool for charcoal drawings that are saturated with charcoal dust.

**6.** Using the kneaded eraser, restore the white of the paper on the coffee pot. The light drawing against the darkness is nothing more than the work of the kneaded eraser.

**7.** Shade the light areas with the kneaded eraser to lessen the harsh contrast between light and dark. Then do some light blending to give the exercise the final touch.

**LEVEL OF DIFFICULTY**
★
**TOOLS**
Sanguine Pencil
**SUPPORT**
90 lb (200 gr) Medium Textured Paper

**Artists that have some experience drawing with charcoal and sanguine will not have great difficulties working with pastels. In this exercise, you will take up sanguine again, a type of red pastel that you used in the previous section. Here you will focus on its chromatic qualities and a technique for blending it, both characteristic of working with any pastels.**

**1.** First, make a drawing that precisely outlines the three pears that will be the subject of this exercise.

**2.** Color the central part of each pear with sanguine. Here you will use a sanguine pencil, but you could also use a sanguine stick, or even a conventional pastel stick.

**3.** Spread the sanguine that you just applied with your finger over the entire surface of the pears to create light shading.

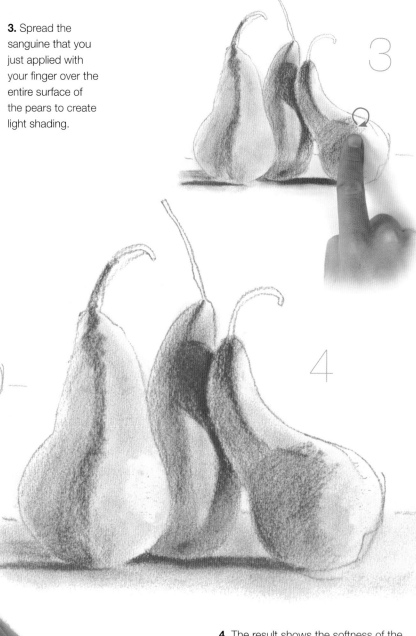

**4.** The result shows the softness of the blending and the intensity of the color you can achieve when working with sanguine, which is a variation of drawing with pastels.

**LEVEL OF DIFFICULTY**

★

**TOOLS**

Pink and Light Sienna Pastel Sticks
Natural Charcoal Stick

**SUPPORT**

90 lb (200 gr) Medium Textured Paper

Modeling with charcoal consists of creating a play of light and shadows that is rich enough to suggest the relief of an object and to locate it in the physical space. It is the same when modeling with pastels, to a certain point, although in this case the suggestion of relief is sacrificed in favor of the representation of color, which is absent from charcoal drawings.

**1.** Draw a dog with charcoal, but do not worry about the details and the play of light and shadow.

**2.** Color the areas that will be darkest with the pink pastel stick: the ears, the nose, the legs, the tail, and the chest. Add a few lines with the light sienna pastel over the pink.

**3.** Now blend the previous applications of color with your finger to unify the tone and to model the anatomical shapes of the dog.

**4.** Draw over the blended pastel colors with the charcoal stick to create the final details of the head.

**LEVEL OF DIFFICULTY**
★
**TOOLS**
White Pastel Stick
Sanguine Pencil
Blending Stick
Cotton Rag
**SUPPORT**
90 lb (200 gr) Medium Textured
Tan Paper

**Color paper is the most common support for drawings made with pastels. Colored lines seem to require a background color, which helps create an overall harmony for the combinations of color, especially when the drawing, like this one, is made with a very small range of colors.**

**1.** The tan color of the paper is similar to the color of the sanguine, but much lighter. The sanguine line that you will use to block in the shape of this snail shell harmonizes perfectly with the tone of the paper.

**2.** Use the blending stick on the drawing to create an even shading by simply rubbing the lines.

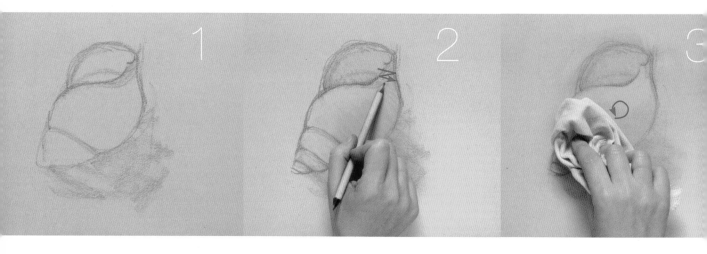

**3.** Rub the drawing with a clean cotton rag to remove the extra lines and any marks left by the blending stick.

**4.** Now all you have to do is apply white on the highest areas of the shell and lightly blend it to create a beautiful pastel drawing with strong relief.

**LEVEL OF DIFFICULTY**
★
**TOOLS**
Mauve, Gray, Black, and White
Pastel Sticks
**SUPPORT**
90 lb (200 gr) Medium Textured
Blue Paper

**The artist has many colors of paper to choose from, and the choice will depend on the kind of drawing and the effect he or she wishes to create in the drawing. In this exercise, you will be working with cool colors and drawing on paper that also has a cool color, with quite a dark tone.**

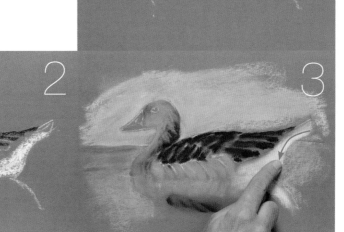

**1.** Make a very simple drawing with white pastel. It should be a simplified version of a previous sketch made with a pencil, whose lines are still visible in some areas of the paper.

**2.** Add small strokes on different parts of the duck as shown in this illustration: use black, gray, and white.

**3.** Blend the previous colors with your finger; also color and then blend the upper part of the drawing with white and gray and add mauve in the lower part to indicate the water.

**4.** The drawing will be finished after all the colors of the drawing have been blended and the texture of the surface unified.

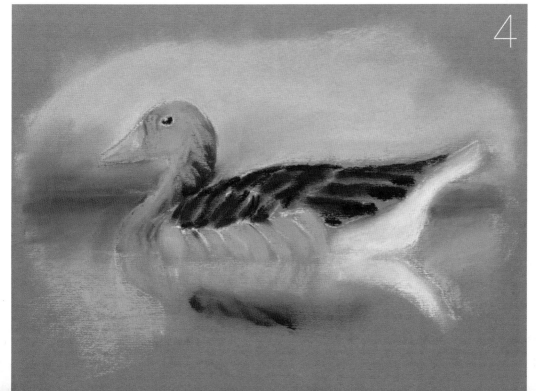

**LEVEL OF DIFFICULTY**
★ ★

**TOOLS**
White, Yellow, Red, Blue, and
Green Pastel Sticks

**SUPPORT**
90 lb (200 gr) Medium Textured Green Paper

In the following exercise, you will see how bright saturated colors can harmonize with other vibrant tones in a drawing, rather than clashing. Here spring flowers are the subject of the drawing.

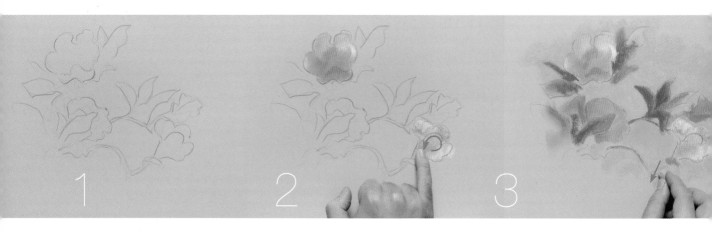

**1.** Start with a few pencil lines as guides; then draw the flowers and the stems with green and red pastel sticks without applying too much pressure or making very heavy lines.

**2.** Add light strokes of red, yellow, and white on two of the flowers, and then rub and blend the colors with your finger.

**3.** Leave some of the colors unblended, that is to say, the green leaves, so they will contrast with the flowers. This way the contrast is not only the color but the texture.

**4.** Finally, surround the leaves and flowers with blue pastel to unify the drawing and create a strong contrast against the bright green of the paper.

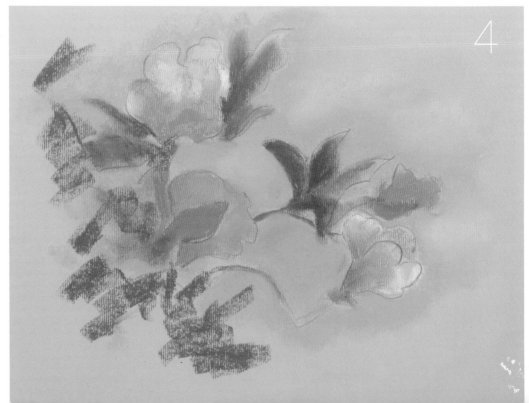

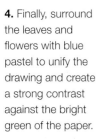

**LEVEL OF DIFFICULTY**
★
**TOOLS**
Light Blue and Dark Blue
Pastel Sticks
Rubber Eraser
Cotton Rag
**SUPPORT**
90 lb (200 gr) Medium
Textured White Paper

1

**Pastel can be erased, but not as easily as natural charcoal. In this exercise, you will make a drawing with a stick of pastel and use a rubber eraser to make white lines in the blended blue pastel.**

**1.** Color the paper with wide strokes of the two blue pastel tones, the darker at the bottom and the lighter above.

2

**2.** Rub the pastel with the rag to create a uniform tone. The lower area will be darker but with a very smooth texture.

3

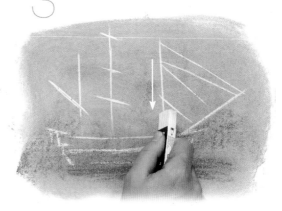

**3.** Use a corner of the eraser to "draw" white lines that are actually the color of the paper. The eraser must be made of rubber, harder than the usual kneaded eraser that is used when drawing with charcoal.

4

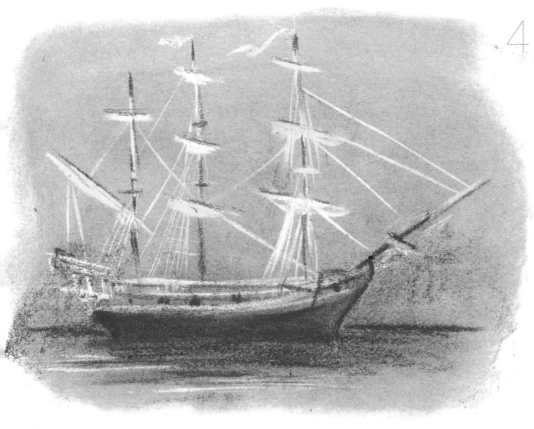

**4.** Add some final lines with the dark blue pastel to add depth to the drawing. The resulting sailing ship was made without a great amount of effort.

**LEVEL OF DIFFICULTY**
★
**TOOLS**
White, Ochre, Orange, Yellow, Sienna, Pink, Gray, and Blue Pastel Sticks
**SUPPORT**
90 lb (200 gr) Medium Textured Gray-Green Paper

Works done with pastel are halfway between drawings and paintings. This exercise shows a drawing that could also be considered a painting because it is done with many different colors. It is a drawing that is colored, and the colors are also part of the drawing because the lines are made with the colors.

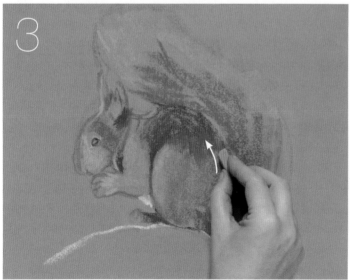

**1.** Make a drawing of the squirrel with an orange pastel, using white to outline the base that the squirrel is sitting on.

**2.** Continue to color the body with the orange pastel. Add some ochre over some of the areas, and also add a little bit of pink to the lines on the tail.

**3.** Add sienna in the areas that require a darker tone, and then shade it with some applications of orange. The head consists of a white spot for the nose and a blue mark on the eye.

Add cool gray and blue tones to the inside of the ear. As you accumulate stokes of color in a pastel drawing you should not blend them because you will muddy the colors. You should leave the marks made by each pastel one on top of the other.

**4.** The strokes of color also fulfill a drawing function because the directions of the lines describe the fur of the squirrel.

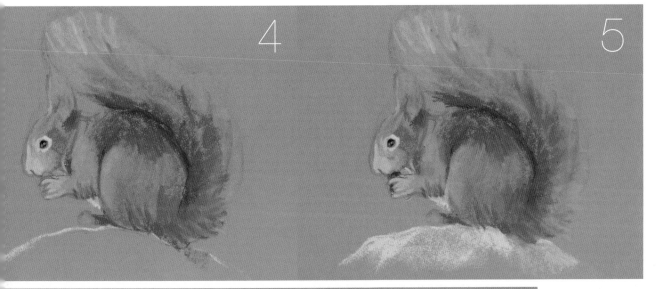

**5.** The fur of the squirrel can be very well represented on the paper by light strokes of the pink and sienna pastel sticks.

**6.** Finally, add a few yellow lines to brighten the fur without altering all the modeling and coloring you have done on this drawing.

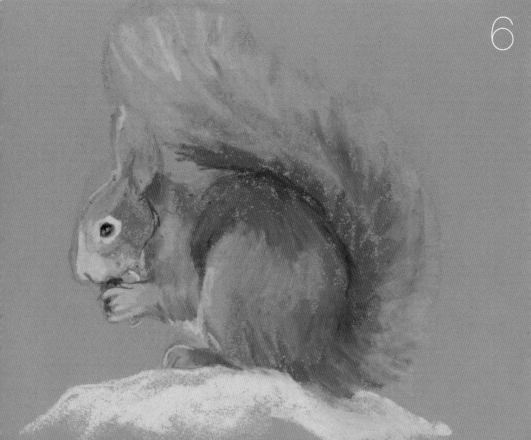

**LEVEL OF DIFFICULTY**

★

**TOOLS**

Burnt Sienna, Ochre, Pink, Mauve, Blue, Light Gray, Dark Gray, and Black Pastel Sticks

Fine Point Black Marker

**SUPPORT**

90 lb (200 gr) Medium Textured White Paper

**Pastel is a drawing medium that has a blurred, colorful finish. Marker lines are the exact opposite: markers are a medium that guarantees precise and clear lines. Despite their intrinsic differences, they can be combined very easily as long as you do not try to confine the strokes of pastel within the lines drawn with the marker.**

**1.** Draw the subject in pencil, and then go over the lines with a fine point black marker simplifying the details wherever possible so that there will not be too many black lines in the finished work.

**2.** Begin spreading pastel in the background of the drawing. Use a stick of burnt sienna, drawing a few lines on the paper and then blending them with your finger. Do not try to accurately follow the edges indicated by the black lines.

**3.** The colors that must go into the narrowest and the smallest areas should be applied carefully. A single black or pink line can be blended to define the color of a selected zone. Use ochre to color the face.

**4.** Finally, paint the clothing with mauve, blue, and light and dark gray. For the final effect, it is not important if some of these colors go outside the lines and into other areas of the drawing.

**LEVEL OF DIFFICULTY**
★ ★
**TOOLS**
White, Yellow, Pink, Green, Blue,
Rust Red, and Gray Pastel Sticks
Round Watercolor Brush
India Ink
**SUPPORT**
90 lb (200 gr) Medium Textured
White Paper

**Pastels can easily be integrated with any other drawing medium as long as water is not involved. In this case, you will combine it with an ink wash, but you will apply the pastels when the wash is dry. We give you little information about ink washes here; however, there will be much more on the subject in the next section of this book.**

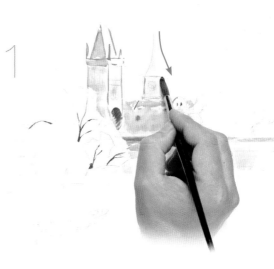

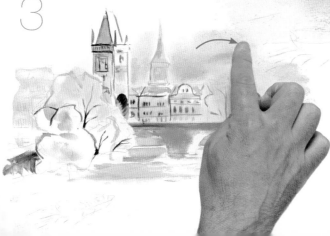

**1.** Draw the subject in pencil and then go over some of the lines with the tip of the brush. Use the same brush to paint a very diluted ink wash over the drawing.

**2.** This is what the wash looks like. The pastel will not always stay within the lines of the drawing, but it will be based on this distribution of lines and tones when adding color.

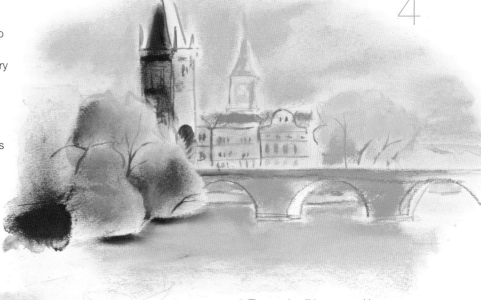

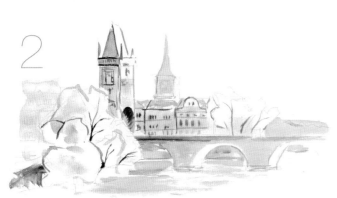

**4.** The wash will be covered in some places but visible beneath the blended pastel in others.

**3.** Apply the pastel lightly, barely coloring the paper with the stick and then spreading it as much as you can with your finger.

**LEVEL OF DIFFICULTY**

★

**TOOLS**

Yellow, Orange, Pink, Ochre, Green, Burnt Sienna, and Blue Pastel Sticks Red, Green, Blue, and Black Markers

**SUPPORT**

90 lb (200 gr) Medium Textured White Paper

**Although this exercise is very simple, the finished work will have a rich and complex look. As with some of the previous exercises, it consists of clearly separating the functions of drawing and of coloring, creating a detailed drawing before adding any pastel colors.**

**1.** Draw the subject from start to finish. In this case, the model is the architecture on a Venetian canal with all of its intricate combinations of doors and windows.

**2.** Now redraw the lines using markers of different colors. Use several colors for the lines to create a lot of variation in the picture.

**3.** This is similar to what your drawing should look like after going over the lines with the markers. Leave some details unfinished so that you have the freedom to use different markers on them later based on the overall appearance of the work.

**4.** Apply some pastel on the paper making light marks with the stick, and then rub them with your finger or with a clean cotton rag.

**5.** Little by little, darken the various colors on the entire drawing. The right side of the composition should be darkened with some burnt sienna.

**6.** Finish the drawing with a marker, choosing the color you will use based on the look of the drawing. The pastel will not hinder the use of the marker as you draw.

Lines made with markers are permanent and cannot be affected by rubbing. The different colors of marker create different effects when combined with pastels that are rubbed and blended.

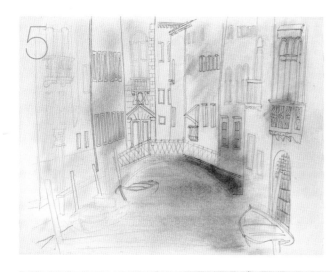

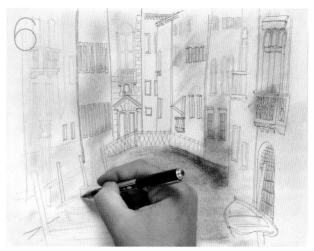

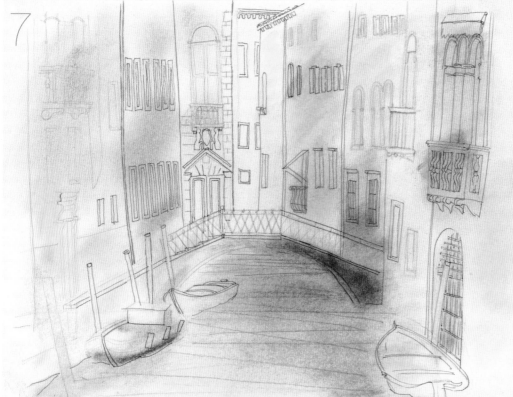

**7.** The final effect is a drawing with a lot of details and rich atmospheric colors that perfectly combine with the characteristics of the chosen subject matter: a picturesque corner of the city of Venice.

**LEVEL OF DIFFICULTY**
★
**TOOLS**
Ochre, Orange, Green, Blue, Violet, and White Wax Crayons
**SUPPORT**
100 lb (250 gr) Medium Textured Paper

Color wax crayons are similar to pastels. In fact, they are an oil-based version of them, but they are difficult to blend and cannot be erased. On the other hand, they can be diluted with certain solvents and even blended if heat is applied to them. In this exercise you will learn how they can be directly employed in the drawing.

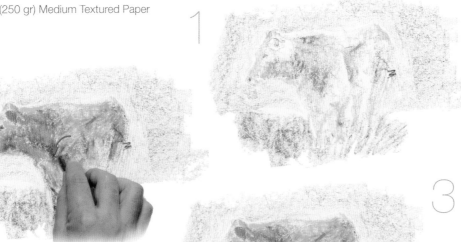

**1.** If you rub wax crayons lightly over the paper, they will leave faint marks, and this will allow you to make a rough initial sketch.

**2.** Add ochre over some orange lines to create a partial mixture of the two colors that looks like the color of the cow.

**3.** Add the color of the grass in the field with vertical lines, applying quite a bit of pressure on the paper.

**4.** Superimpose some colors in the sky using the sides of the crayons on the paper. Use blue and violet for this, then blend them by applying white on top of them.

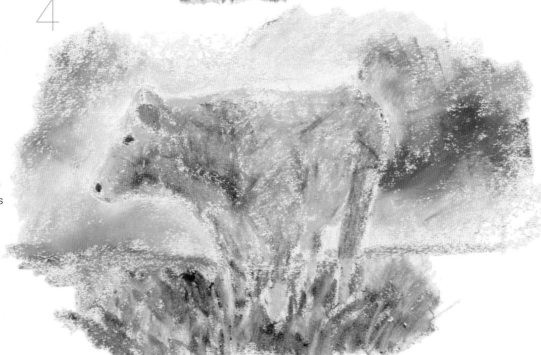

**LEVEL OF DIFFICULTY**
★ ★

**TOOLS**
Yellow, Red, Green, Blue, Pink, Violet, and White Wax Crayons
Spatula

**SUPPORT**
100 lb (250 gr) Medium Textured Paper

Building up strokes of wax color will create crumbs of pigment that can be worked (by flattening) with a spatula. In this exercise, you will follow this working method step by step and move past the limits of drawing and almost fully enter the territory of painting.

**1.** Make a basic drawing with a pink wax crayon; these lines will disappear under later applications of color.

**2.** Use a little blue to outline the drawing and in the center use yellow and red to create the actual color of the apple.

**3.** The repeated applications will create some crumbs on the surface of the paper that you can now work with a spatula, spreading and mixing the colors.

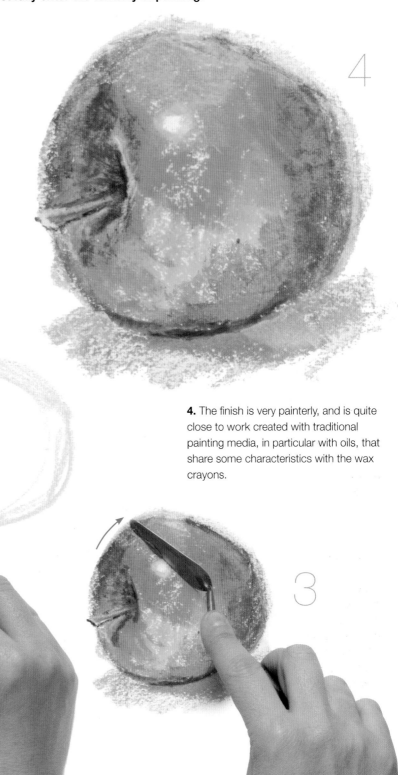

**4.** The finish is very painterly, and is quite close to work created with traditional painting media, in particular with oils, that share some characteristics with the wax crayons.

**LEVEL OF DIFFICULTY**
★

**TOOLS**
Sienna, Pink, Gray, and Blue
Wax Crayons
Flat Hog Bristle Brush

**SUPPORT**
100 lb (250 gr) Medium Textured
Paper

**Wax crayons, like all the rest of the oil-based media including oil paint, can be diluted with turpentine. In the following approach, you will see the results of making a drawing with wax crayons and then diluting the lines with a brush dipped in the solvent.**

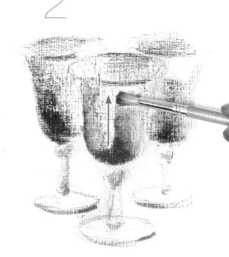

**1.** Draw the glassware with a gray wax crayon, and then color the interiors with blue.

**2.** Dip the brush into turpentine and brush it on the color, which will react like watercolor, spreading easily across the surface of the paper.

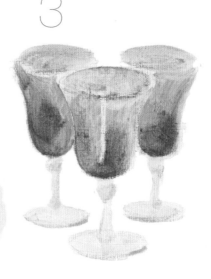

**3.** Paint the interiors of the glasses with the solvent and color, then do the same on the bases of each one of them.

**4.** To finish, very lightly color the background with a pink crayon and the bottom of the drawing with sienna. Just a few passes with the brush will dissolve the color and spread it.

**LEVEL OF DIFFICULTY**

★

**TOOLS**

Yellow, Dark Green, Light Green, Blue Green, Turquoise Blue, Blue, Light Gray, and Black Pastel Sticks
Nib Pen

**SUPPORT**

100 lb (250 gr) Medium Textured Paper

The technique that is illustrated here is typically done by children, but that does not mean it has no value from a creative point of view. It consists of covering a multicolored surface with a dark tone, black in this case, that can then be scratched with a pen to create thin lines that allow the underlying colors to show through.

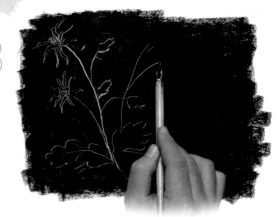

**1.** Cover the paper with areas of color. Use a cool range of blues and greens along with some bright yellow. Here you see we have used dark green, light green, blue green, turquoise blue, and also a light gray.

**2.** Cover the paper completely, adding more blue to the previous colors. Then you can cover the entire paper with solid black.

**3.** Use a nib pen to scratch the layer of black so that the underlying colors "emerge." This technique is called sgrafitto, and it can be done with any utensil that has a point.

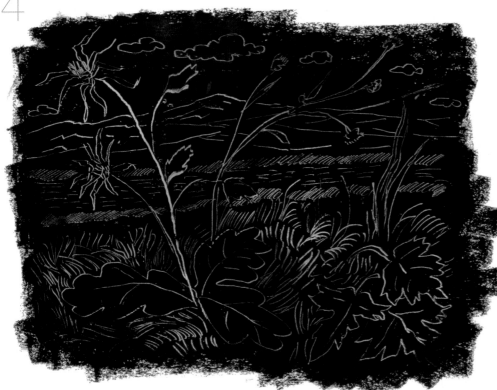

**4.** The look of the finished piece depends as much on the beauty of the colors underneath as on the scratched drawing. You can also vary the color of the top layer, although a very dark tone is generally used.

**LEVEL OF DIFFICULTY**
★

**TOOLS**
Yellow, Red, Blue, Green, Violet,
Gray, and White Wax Crayons
Hair Dryer
Metal Spatula

**SUPPORT**
100 lb (250 gr) Medium Textured Paper

**Wax will melt when heat is applied to it. A hair dryer does a good job of this. When the wax melts, it becomes liquid and can be spread and worked with a spatula, using the sgrafitto technique that was shown in the previous exercise.**

**1.** Apply the colors in the shape of a parrot with multicolored plumage that goes from yellow and red to green and then blue. They should be applied directly to the paper.

**2.** Cover the entire area of the paper surrounding the colors that represent the parrot with a gray wax crayon.

**3.** Now cover the colors of the bird with white wax. Apply heat to the wax stick and spread the melted wax with the metal spatula.

**4.** The colors of the parrot have been completely covered by a thick layer of white wax.

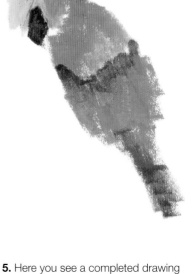

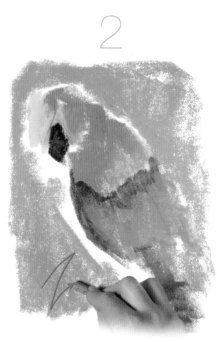

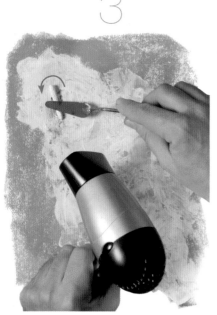

**5.** Here you see a completed drawing of the parrot. The sgrafitto lines vary in thickness because of the rounded point of the metal spatula that we used.

Draw the outline and details of the bird with the spatula. The visibility of the sgrafitto lines depends as much on the tool used for scratching as on the contrast between the color of the surface and the background. In this case both colors tend to be light, so the lines look finer than they really are.

**6.** Add more sgrafitto lines to make the base colors more visible.

**7.** Scratch the beak and the tail of the bird with the spatula to reveal larger areas of the base colors, and then you can consider the exercise finished.

**LEVEL OF DIFFICULTY**
★

**TOOLS**
Various Greens and Blues, Yellow, Purple, and Brown Color Pencils

**SUPPORT**
100 lb (250 gr) Smooth Paper

Line and color (color lines) are the result when an artist uses color pencils as his or her medium. These tools do not cover a large amount of space, so artists are generally limited to working with hatch lines and other types of line work with the different colors.

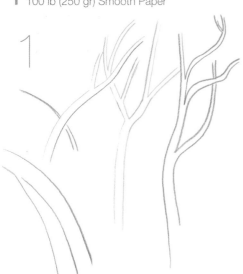

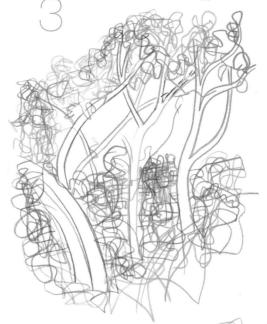

**3.** The lines that make up this loose hatch work are all curves. Avoid angles and zigzag lines that would destroy the harmony and the continuity of the entangled lines.

**4.** Here is a graphic and lively drawing whose visual interest rests in the richness of tones and the complexity of the hatch lines.

**1.** Begin by drawing some tree trunks that you can use as a reference in a free representation of a forest.

**2.** The loose lines used in this exercise will consist of an accumulation of strokes and lines that evoke the dense foliage. Use pencils of many different blue and green colors, including the green ochre pencil you see in this photograph.

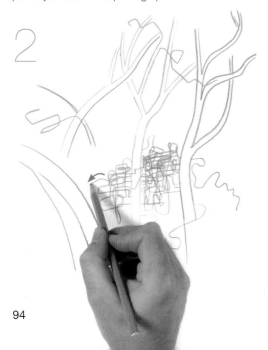

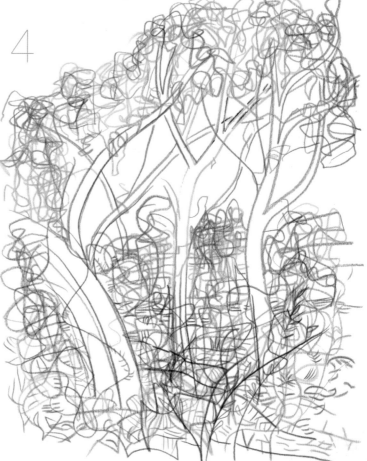

**LEVEL OF DIFFICULTY**
★

**TOOLS**
Yellow, Red, Pink, Violet, Orange, Light Blue, Dark Blue, and Green Color Pencils

**SUPPORT**
100 lb (250 gr) Smooth Paper

**If you are using high-quality color pencils, and you apply enough pressure on the paper, the result will be clearly visible strokes of bright color. In this exercise, you will draw a bull using both light and vigorous lines.**

**1.** Use individual strokes of dark blue to construct a simple outline of the bull.

**2.** Add some light hatch lines, and curve them to suggest the volume of the body of the bull.

**3.** Darken the outlines to evoke the energy of the bull, adding more colors with broken lines of light blue, red, and green.

**4.** Add more colors to the outline and also a few to the hatch interior lines (green and yellow) to finish this drawing, which now expresses dynamism and strength.

**LEVEL OF DIFFICULTY**
★ ★
**TOOLS**
Ochre, Blue, Gray, Yellow, Red, Violet, Pink, and Several Green Color Pencils
**SUPPORT**
100 lb (250 gr) Smooth Paper

The color pencil drawing that we propose here is somewhat more complex than those on the previous pages. The subject is a bunch of different varieties of flowers and stems that require different treatments. Various lines and different areas of closely spaced lines will help create more solid colors.

**1.** The initial drawing must be detailed to avoid hesitation during the course of this exercise. Use a 2B graphite pencil and only utilize lines for the drawing.

**2.** First draw the iris, and add diverse hatch lines on the petals with violet, pink, and red. Apply dark green lines, closely spaced, on the stem.

**3.** Use a very light green and ochre for the smaller stems, covering them completely with lines.

**4.** Draw the largest surfaces with hatch lines, that is, separate and visible pencil lines on which you will superimpose additional color lines.

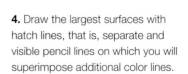

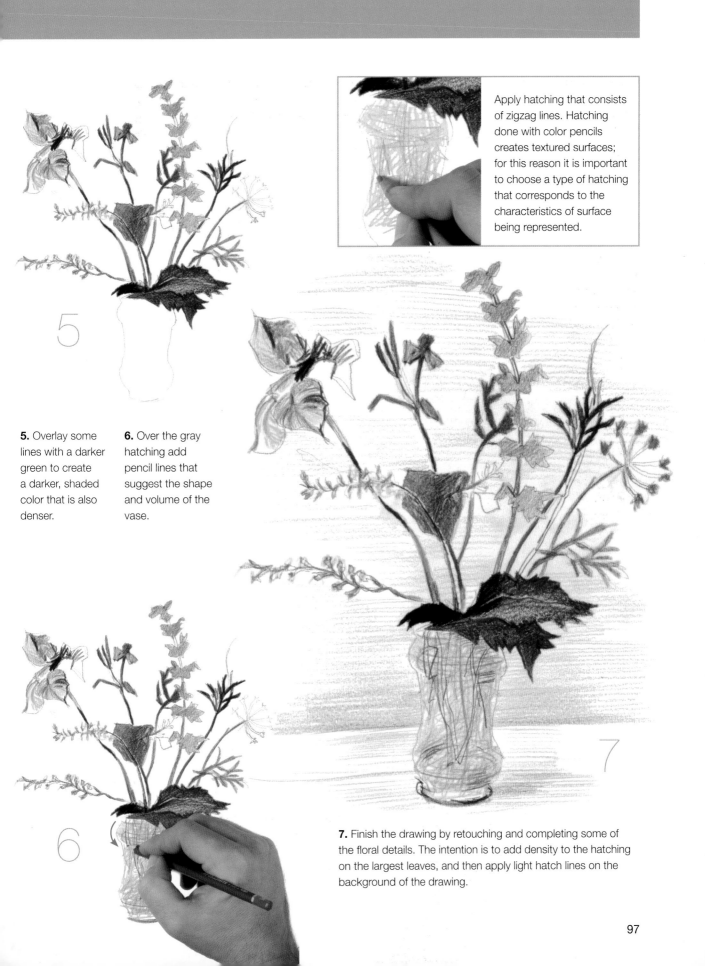

Apply hatching that consists of zigzag lines. Hatching done with color pencils creates textured surfaces; for this reason it is important to choose a type of hatching that corresponds to the characteristics of surface being represented.

**5.** Overlay some lines with a darker green to create a darker, shaded color that is also denser.

**6.** Over the gray hatching add pencil lines that suggest the shape and volume of the vase.

**7.** Finish the drawing by retouching and completing some of the floral details. The intention is to add density to the hatching on the largest leaves, and then apply light hatch lines on the background of the drawing.

**LEVEL OF DIFFICULTY**
★
**TOOLS**
Yellow, Pink, Orange, Blue, Green, Violet, and Gray Color Pencils
**SUPPORT**
100 lb (250 gr) Smooth Paper

**This exercise consists of creating a graphic configuration based on a street scene using a simplified style, with no shading or chiaroscuro, and barely anything other than a series of separate lines of contrasting colors.**

**1.** This drawing requires freely drawn lines; a realistic representation is not as important as a full and varied development of the lines and graphic symbols.

**2.** You should reduce all the figures to their basic features so they will be recognizable and different from each other.

**3.** The differences in size and colors are the key to this drawing, which is really more of an illustration than a representation. The graphic symbols that define the figures are an attempt at clear and simple characterization rather than realism.

**4.** The few hatch lines on the background create a lightly shaded background that helps to emphasize the figures.

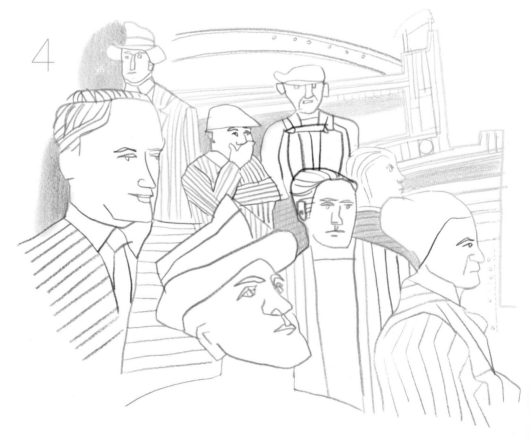

**LEVEL OF DIFFICULTY**
★

**TOOLS**
Green, Ochre, Blue, Violet, and Pink Color Pencils

**SUPPORT**
100 lb (250 gr) Smooth Paper

**The following drawing made with color pencils will have an Impressionistic treatment. The lines should look spontaneous, and the tones should be combined in a bold and loose manner.**

**1.** Draw the general outlines with green, blue, and ochre, leaving open spaces between the lines so they do not fully define the shape.

**2.** Now cover the lower part of the foliage, which is always in shadow, with a blue pencil, applying pressure to create an area that is quite dense.

**3.** Draw the illuminated part of the tree with green and ochre, building up loose hatching and making zigzag motions.

**4.** The sky consists of a series of long hatch lines that are quite light. The rest of the elements of the landscape, which complete the background of the composition, are of similarly light tones.

**LEVEL OF DIFFICULTY**
★ ★

**TOOLS**
Sienna, Green, Dark Blue, Light Blue, Mauve, Pink, and Burnt Sienna
Color Pencils

**SUPPORT**
100 lb (250 gr) Smooth Paper

Color pencils are a perfect medium for drawing portraits and creating the light modeling of the face. The lightly saturated colors and their fine lines can easily be adjusted very precisely to changes of color and tone. In this exercise, we show you the process of making a conventional portrait with color pencils.

**1.** It is important to begin with a good line drawing, simple and without superfluous details, but done carefully enough so that nothing will have to be rectified during the drawing process.

**2.** Go over the lines of the hair and the face with sienna, and define the main areas of shadow with a blue pencil by applying hatch lines.

**3.** With sienna again, and also a green pencil, create the texture, the volume, and the color of the hair by drawing long lines of both colors combined in very dense hatching.

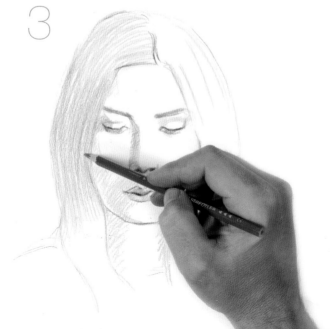

**4.** Go over the eyebrows with burnt sienna and add new hatch lines of mauve over the shadows to add some nuance to the initial blue areas.

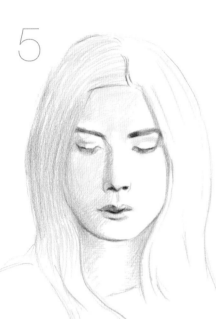

**5.** To complete the modeling of the face, add pink to the blues and mauves to create a smooth transition between the shadows and the illuminated areas.

**6.** The drawing is nearly finished thanks to the successive layers of light hatch lines that shade the surface and modeling little by little.

By going over the line between the hair and the face with a blue pencil, you will be able to separate both areas and suggest a shadow projected on the face of the figure. Draw a single, very dark line.

**7.** Finally, add some more hatch lines with sienna to give the hair greater density of color. This added volume in the hair creates a pleasant contrast with the softness of the pale face.

**LEVEL OF DIFFICULTY**
★
**TOOLS**
Burnt Sienna, Ochre, Dark Blue,
Light Blue, Violet, Pink, and Red
Color Pencils
**SUPPORT**
100 lb (250 gr) Smooth Paper

Drawings made with color pencils are always based on lines, either by themselves or as part of hatching. Hatching is usually applied in two crossing directions, but in some cases you can apply all the hatch lines in a single direction and create an effect similar to that of a print.

**1.** Start with a very precise drawing that defines the areas of light and shadow in the subject. The face is clearly divided into the illuminated part and the shaded part.

**2.** Fill the shaded part with vertical hatch lines of dark blue and violet. The hatching should become darker as you progress in the drawing.

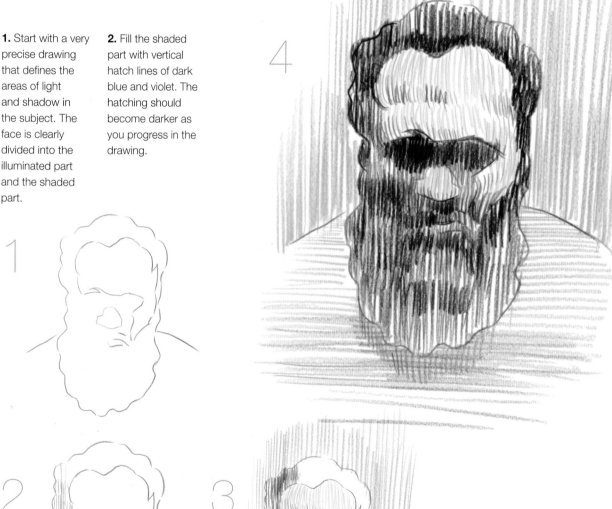

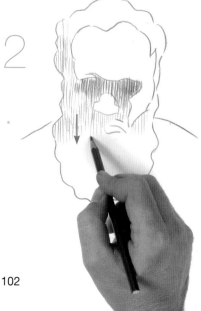

**3.** Apply more pressure in the eyes to emphasize the shadow. Use ochre and burnt sienna in the rest of the illuminated areas.

**4.** The hatching looks darker where the shadows are more intense, so the hatching in the background should be light and uniform, with an overall even tone.

**LEVEL OF DIFFICULTY**
★

**TOOLS**
Burnt Sienna, Light Green, Dark Green, Dark Blue, and Pink Color Pencils

**SUPPORT**
75 lb (160 gr) Smooth Paper

**In this exercise you will use a textured base to create an initial pattern. The base can be any surface that has relief; here we used a mat that produces a texture on the paper (a more or less thin paper) by just rubbing a color pencil across it.**

**1.** While holding the paper firmly on the small mat, rub the areas around the drawing with a burnt sienna pencil, which you can darken with the dark blue.

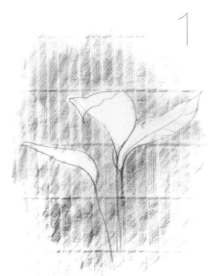

**2.** Now cover the leaves, alternating light green and dark green lines to create a certain amount of modeling.

**3.** Color the undersides of the leaves with pink first, as well as the stems, which were previously drawn with blue and green.

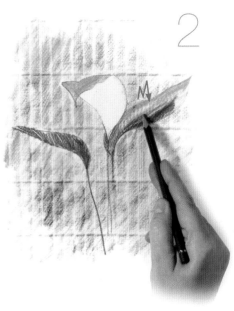

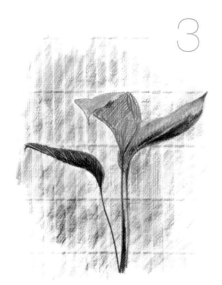

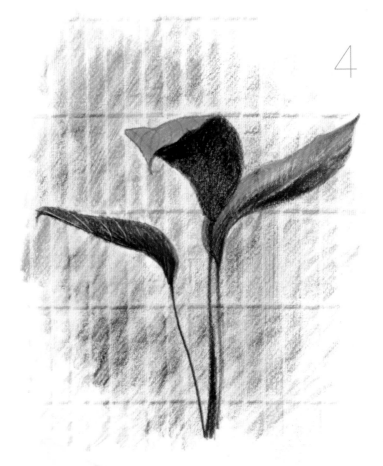

**4.** Adding the pink over the dark blue creates a very dark color that acts as the shadow of the leaf. This simple effect of texture gives the drawing a special sense of dimension.

**LEVEL OF DIFFICULTY**
★ ★

**TOOLS**
Gray, Light Blue, and Dark Blue
Color Pencils

**SUPPORT**
140 lb (300 gr) Smooth Paper

One way of altering and modifying the finish of color pencil drawings
consists of embossing the surface of the paper, forming it with some
blunt tool (to avoid tearing the support). In this exercise you will achieve
an interesting textural effect using this method.

**1.** After making a
pencil drawing, go
over the essential
lines with a gray
color pencil. This
initial sketch will be
the foundation for
the lines and colors
seen in the final
version.

**2.** Now use a
spatula with steel
teeth (or any
toothed object).
The teeth should
not be sharp, but
have rounded
ends. Create a
sinuous texture
on the body of
the bird.

**3.** Draw and color
on the paper with
light blue and
dark blue, and the
grooves created
with the toothed
object will appear.

**4.** Here you see
in advance what
the texture on
the bird's body
will look like. The
effect evokes the
qualities of the
plumage.

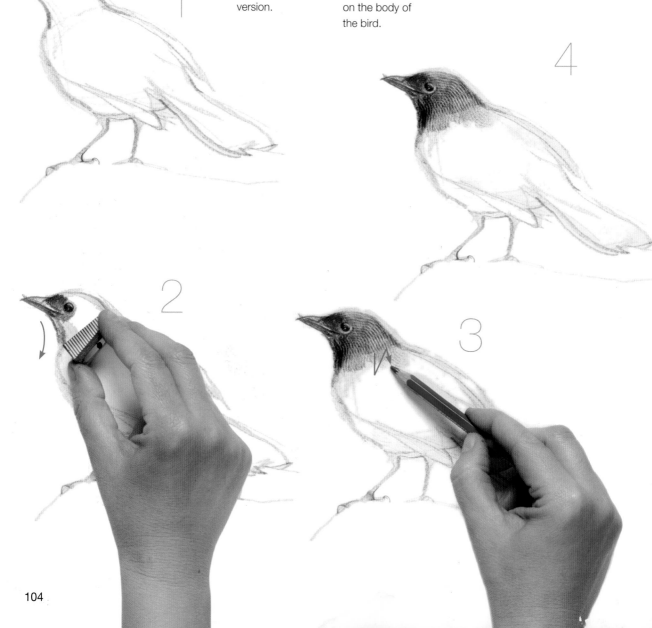

**5.** Now combine the dark blue with gray to accentuate some tones of the feathers that will create an effect of volume and relief.

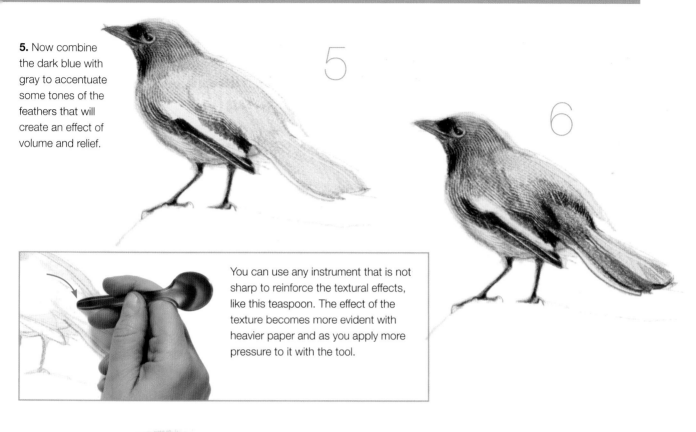

You can use any instrument that is not sharp to reinforce the textural effects, like this teaspoon. The effect of the texture becomes more evident with heavier paper and as you apply more pressure to it with the tool.

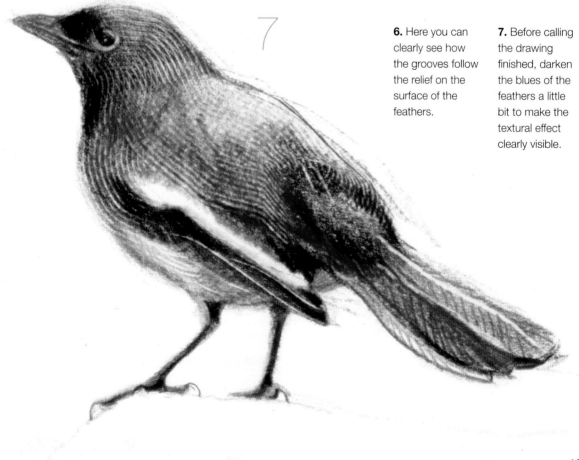

**6.** Here you can clearly see how the grooves follow the relief on the surface of the feathers.

**7.** Before calling the drawing finished, darken the blues of the feathers a little bit to make the textural effect clearly visible.

**LEVEL OF DIFFICULTY**
★ ★
**TOOLS**
Sienna, Burnt Sienna, Yellow, Ochre, Raw Umber, and Gray Color Pencils
**SUPPORT**
140 lb (300 gr) Smooth Paper

**Embossing the paper prior to drawing can be a way to create hatching. In the following technique, you will use an empty ballpoint pen to build up hatch lines on the paper that will later become visible when you draw over them with color pencils.**

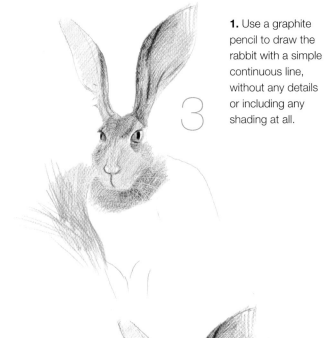

**1.** Use a graphite pencil to draw the rabbit with a simple continuous line, without any details or including any shading at all.

**2.** Add the hatching with the empty ballpoint pen; the small ball on the point will keep the paper from tearing. You should draw the hatch lines as if you were drawing the fur on the rabbit, using short and closely spaced lines.

**3.** Use sienna, ochre, and raw umber to create an accurate combination of tones that emphasize the texture of the embossed paper and a convincing representation of the fur.

**4.** Draw the grass surrounding the rabbit with ochre, making long lines that represent the wild flowers and grasses.

When you draw on embossed paper, the lines created with the ballpoint pen become visible. This is when you can begin to see the results of the embossing you did earlier. If you see that you have not made enough lines, you can go back over the paper with the ballpoint.

**5.** Add a few darker lines to complement the ochre grasses; this will add more relief and consistency to the bunches of grass and stems.

**6.** Finish the rabbit by covering its body with the same combination of colors used on the head.

**7.** These grasses create a context and an environment for the figure of the rabbit. Its coloring is reinforced and shaded by the embossed lines you made on the paper at the beginning of the process.

**LEVEL OF DIFFICULTY**

★

**TOOLS**

Red Water-Soluble Color Pencil

2B Graphite Pencil

Round Watercolor Brush

**SUPPORT**

100 lb (250 gr) Smooth White Paper

**The major manufacturers of color pencils also offer water-soluble varieties, with pigment that can be diluted with water. The watercolor pencil process normally consists of drawing on the paper, then spreading the color pigment contained in the lines with a brush dampened with water.**

**1.** Draw the figure with a graphite pencil. Coloring the figure will be separate from these lines and will consist of spreading a color wash to emphasize the light and shadows.

**2.** Draw on the figure's shoulder, pressing hard enough on the pencil to deposit a lot of pigment on the paper. Then spread the pigment with a brush that is dampened with water.

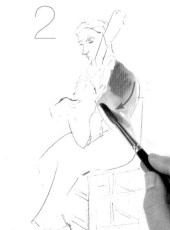

**3.** After extending the wash over the figure, you will see the contrast between the lines, which are a darker red, and the lightness of the color wash.

**4.** Finally, color the background and the shadow cast by the figure using a single water-soluble pencil.

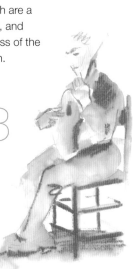

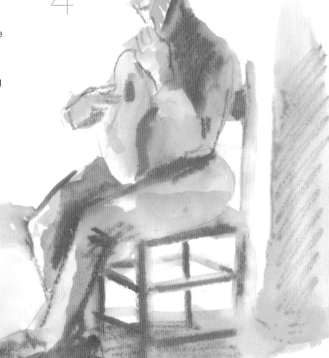

**LEVEL OF DIFFICULTY**
★
**TOOLS**
Red, Orange, and Green
Water-Soluble Color Pencils
2B Graphite Pencil
Round Watercolor Brush
**SUPPORT**
100 lb (250 gr) Smooth White Paper

In this exercise, you will see how lines made with water-soluble pencils can be diluted to the point of being nearly imperceptible when a wash is painted on the paper. To make this possible, you must not apply too much pressure with the pencils.

**1.** Begin with a simple pencil drawing of the peppers that are the subject of this exercise.

**2.** Next, apply the red to the surfaces of the peppers, making sure not to press too hard except in the areas that are in shadow.

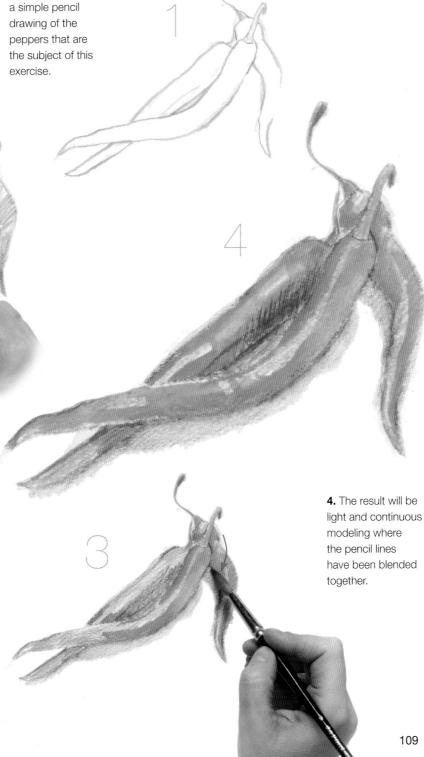

**3.** Cover the parts that were not colored red with orange pencil. Then paint the stems green and also add some light hatching with the graphite pencil to represent the shadows. Immediately paint the red and orange lines with a damp brush to blend the two colors.

**4.** The result will be light and continuous modeling where the pencil lines have been blended together.

**LEVEL OF DIFFICULTY**
★ ★
**TOOLS**
Blue, Yellow, Burnt Sienna,
and Orange Water-Soluble
Color Pencils
**SUPPORT**
100 lb (250 gr) Smooth White Paper

Water-soluble color pencils are very effective when they are used for rendering the human figure. Diluting the lines also softens the tones and creates delicate transitions of light and shadow that are particularly favorable in the treatment of the figure.

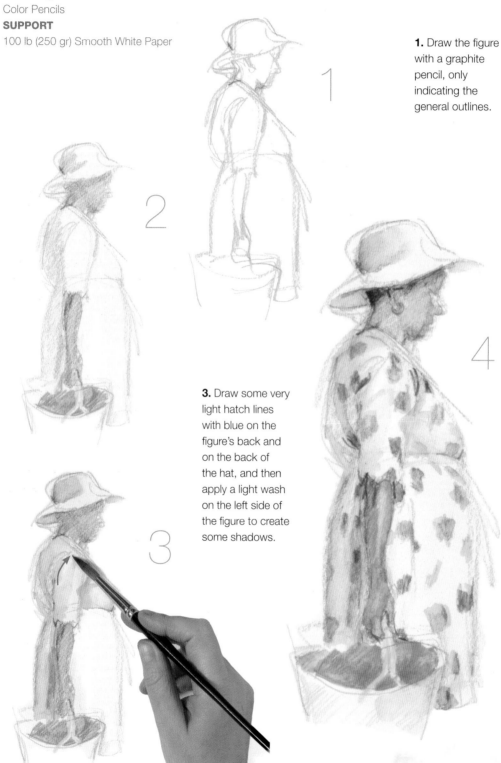

**1.** Draw the figure with a graphite pencil, only indicating the general outlines.

**2.** Add some light hatching with burnt sienna for the flesh tones on the head and arm, and also some dark lines with orange on the interior of the basket.

**3.** Draw some very light hatch lines with blue on the figure's back and on the back of the hat, and then apply a light wash on the left side of the figure to create some shadows.

**4.** Create the pattern on the dress with blue spots overlaid on the blue wash, drawn with more pressure than the previous hatching. And finally, add the details of the face.

**LEVEL OF DIFFICULTY**
★

**TOOLS**
Burnt Sienna, Blue, and Violet
Color Pencils

**SUPPORT**
100 lb (250 gr) Medium Texture
Pink Paper

**Color pencils can be an artist's best friends when he or she needs to do some sketching or make some simple figure drawings. In this exercise, you will learn a very simple and quick technique for making such sketches, using just three color pencils.**

**1.** First draw the basic lines of the figure with the burnt sienna color pencil.

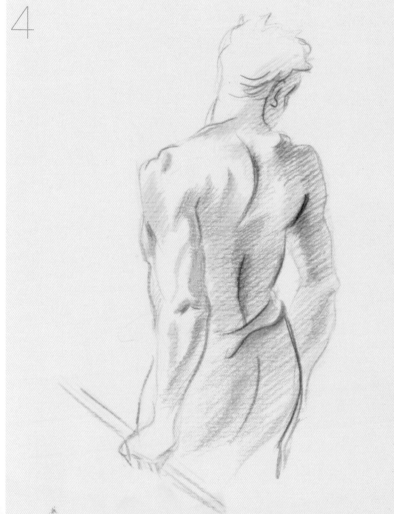

**2.** Draw over the lines that represent the main volumes of the back, and then apply light hatch lines over all the relief on the back using the same burnt sienna pencil.

**3.** Now go over those same forms, as well as the form of the pants, with the blue pencil to create a contrast between the cool color and the warm sienna that will suggest a stronger relief.

**4.** To finish, model the arm with the sienna color and lightly shade the pants with violet.

**LEVEL OF DIFFICULTY**
★ ★
**TOOLS**
Yellow, Ochre, Raw Sienna, Burnt
Sienna, Orange, Red, Green, Gray,
Blue, and Violet Color Pencils
2B Graphite Pencil
**SUPPORT**
100 lb (250 gr) Smooth White Paper

**This exercise demonstrates the laborious technical process that results in a drawing with all of its details shaded and modeled using colored pencils. The subject is a bowl full of different fruits, each one with its own color and texture that requires an individual and detailed treatment.**

**1.** The initial drawing required for this exercise, done with a graphite pencil, is very complete and detailed. Each piece of fruit is defined and located in its specific place and maintains its precise relationship with the rest of the grouping.

**2.** Begin coloring from the left with fairly light tones. First draw with ochre to establish a common base among most of the pieces of fruit. On this base, continue to work with yellow and red, which are the colors that will give the fruit its vivid tones.

**3.** Add green over the ochre base for the greenest pieces of fruit, creating a neutral tone that shows the effect of mixing the two tones, although such a mixture does not exist since one color is actually superimposed on the other.

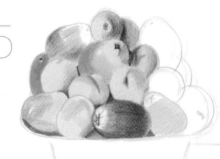

**4.** On the lower part of the grouping, you can see the results of working with layers: very solid modeling in green with very clear relief.

**5.** Now cover the small spaces that exist between the different pieces of fruit. Use blue overlaid on red for this. In the areas where the fruit rests directly on the bowl, use blue for the spaces.

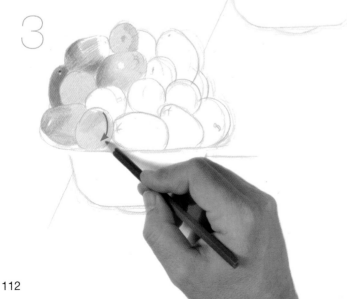

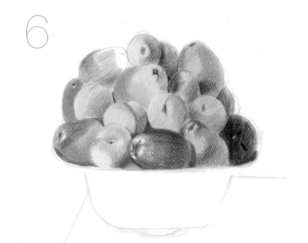

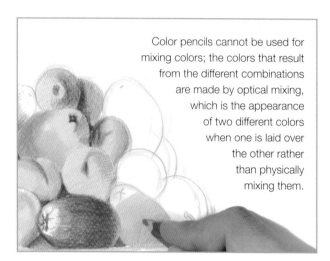

Color pencils cannot be used for mixing colors; the colors that result from the different combinations are made by optical mixing, which is the appearance of two different colors when one is laid over the other rather than physically mixing them.

**6.** Work on all the pieces by lightly overlaying colors, hatching, or layers of one color over another to create the characteristic color and form of each piece of fruit.

**7.** Finally, finish the container with blue and gray shading and also darken the background a little with gray to suggest space, light, and the environment of the subject.

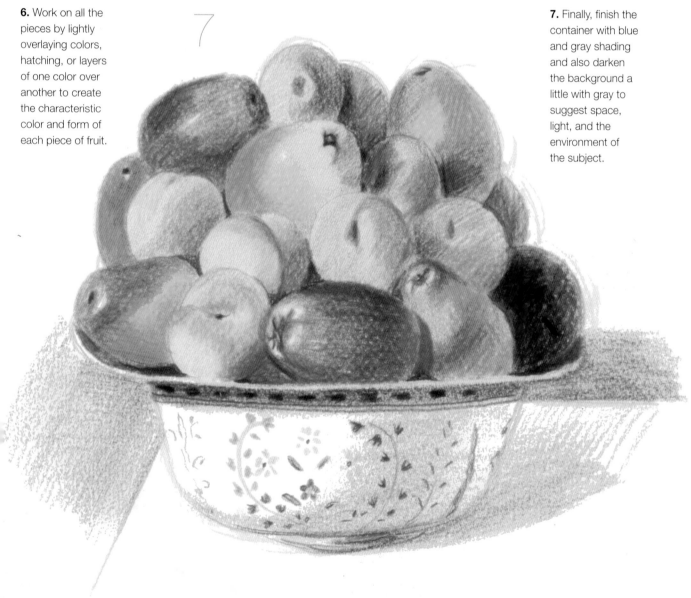

**LEVEL OF DIFFICULTY**
★
**TOOLS**
Yellow, Orange, Red, Burnt Sienna, Light Green, Dark Green, Pink, Gray, Light Blue, Dark Blue, and Violet Color Pencils
**SUPPORT**
100 lb (250 gr) Smooth Paper

**The immediacy of color pencils makes them especially useful for sketching and laying out all kinds of subjects in a very direct and bold way. Here you will see the process of sketching an interior where the elements are emphasized or eliminated according to the perceptions of the moment, focusing on the most contrasting areas, without pausing for corrections or making modifications.**

**1.** First draw the central object in gray, and outline the surface of the table and the window with some blue lines. Quick and simple hatching done in yellow indicates the exterior plane.

**2.** Continue to organize the space of the sketch with more lines, using gray and blue, to mark the position and size of the other window. This light blue highlights the central objects while at the same time marking a plane that is a distance from them.

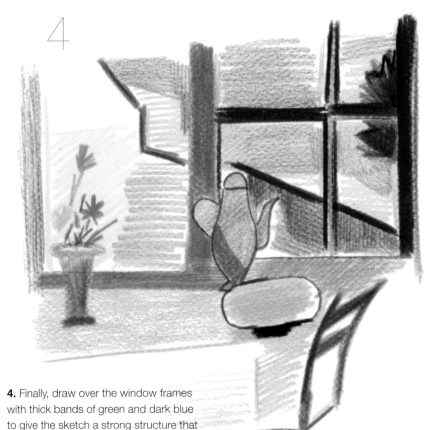

**3.** Now create a play of colorful planes with different closely spaced hatching, drawn quickly; it is important to establish the contrasts and emphasize the dynamic relationships of the planes.

**4.** Finally, draw over the window frames with thick bands of green and dark blue to give the sketch a strong structure that will compensate for all the liberties you have taken with the colors.

**LEVEL OF DIFFICULTY**
★ ★

**TOOLS**
Burnt Sienna, Ochre, and Black
Color Pencils

**SUPPORT**
100 lb (250 gr) Smooth White Paper

**This drawing demonstrates one of the best techniques for the uses of color pencils. It consists of drawing and coloring at the same time so that the line accompanies the colored areas, reducing the dense hatching to strengthen the graphic qualities of the colored lines.**

**1.** Make an initial drawing with the burnt sienna pencil. The drawing should be very cursive, with undulating lines that add dynamism and relief to the subject before it is even shaded.

**2.** This technique consists of drawing constantly. The goat's fur is a good excuse for making curved lines in the interior of the general outline. Add ochre and black lines to achieve a chromatic effect rather than just a drawing.

**3.** Strengthen the lines with some occasional areas of color like the two sienna ones on the goat's side. This will add some body to the drawing and intensify the sense of color.

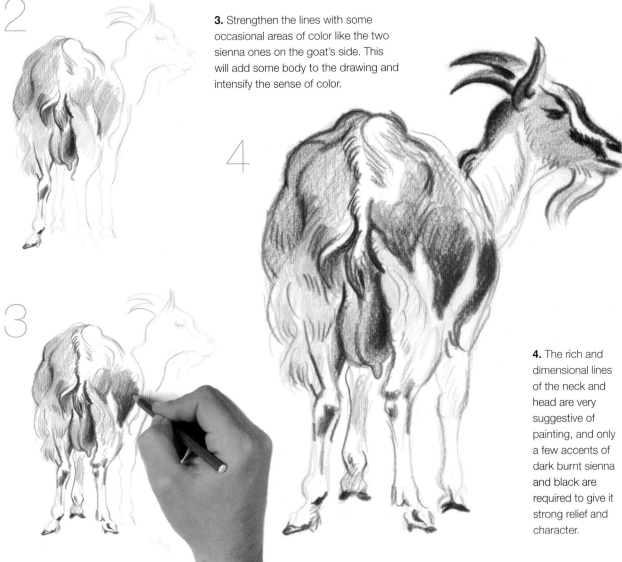

**4.** The rich and dimensional lines of the neck and head are very suggestive of painting, and only a few accents of dark burnt sienna and black are required to give it strong relief and character.

**LEVEL OF DIFFICULTY**

★

**TOOLS**

India Ink

Nib Pen

2B Graphite Pencil

**SUPPORT**

100 lb (250 gr) Smooth Paper

**India ink applied with a nib pen is a very graphic medium, with pure black lines that are nearly identical, which creates a clear contrast between the lines. This time you will draw a simple object as an introduction to the technique of pen and ink line and crosshatching.**

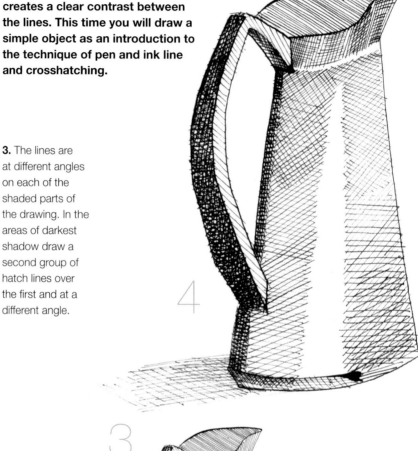

**1.** Draw the container with the graphite pencil, and then go over the lines with the pen, keeping the point in contact with the paper until the ink runs out to create good strokes.

**2.** To shade with hatching, first draw a series of parallel diagonal lines making sure they do not cross each other.

**3.** The lines are at different angles on each of the shaded parts of the drawing. In the areas of darkest shadow draw a second group of hatch lines over the first and at a different angle.

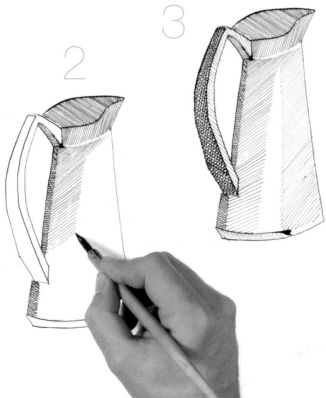

**4.** To accentuate the modeling and the relief of the drawing, darken the shadows with denser hatching, that is, cross the initial hatching with new sets of lines.

**LEVEL OF DIFFICULTY**

★

**TOOLS**

India Ink

Nib Pen

2B Graphite Pencil

**SUPPORT**

100 lb (250 gr) Smooth Paper

Nib pens can make slight variations in the width of the line, variations that can make important graphic accents that complement the lines and dots or stippling that are typical of these pens. In this exercise, you will see some important approaches in the treatment of the lines and the stippling.

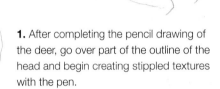

**1.** After completing the pencil drawing of the deer, go over part of the outline of the head and begin creating stippled textures with the pen.

**2.** Continue with the neck and down, creating stippled textures of differing intensities, applying pressure on the paper with the pen where you need wider lines and making denser stippling in areas of shadow.

**3.** It is important to emphasize the irregularities of the texture, which are more or less dense depending on the areas of the deer's fur.

**4.** Finally, darken the tail with dark lines and suggest the landscape using simple lines that indicate the horizon.

**LEVEL OF DIFFICULTY**
★
**TOOLS**
India Ink
Nib Pen
2B Graphite Pencil
Round Watercolor Brush
**SUPPORT**
140 lb (300 gr) Smooth Paper

India ink is easily diluted in water and can be used to create washes of many different intensities, from very light grays to dense blacks. This exercise shows the technique of creating values with washes; here the nib pen shares the stage with the brush.

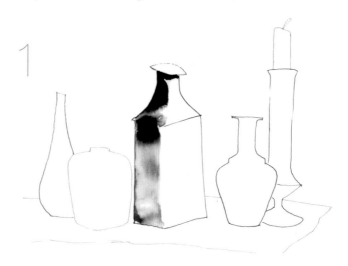

**1.** After drawing the subject with a pencil, go over the lines with pen and ink. On the neck of the bottle, allow the ink to accumulate on one of the lines; then apply a brush that has been dampened with water. The result will be a wash with irregular values that go from intense black to a very light gray tone.

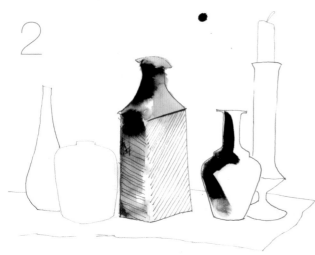

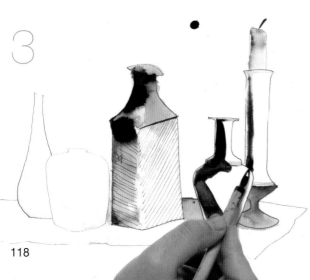

**2.** Repeat the previous operation on the vase that is next to the bottle, and add some widely spaced hatch lines on the bottle.

**3.** Now dampen the neck of the candleholder with the brush, and then draw a line of ink with the pen, allowing the ink to spread along the wet brushstroke.

**4.** This drawing is halfway between hatching and an ink wash; you will use both techniques on it. The range of tones possible in a wash can be seen on the small vase on the left.

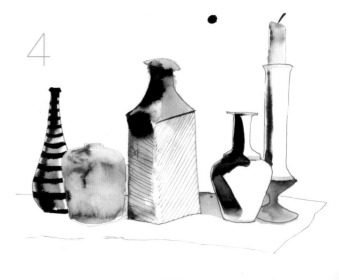

5

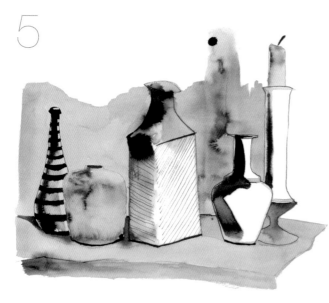

The ink can be spread as if it were watercolor; this wash technique that will allow you to create subtle variations in tone. These tonal variations combine very well with the solid blacks of undiluted India ink.

**5.** Now spread a wash of heavily diluted ink to create a medium gray background with many different shades.

**6.** Finally, add to the hatching on the middle bottle and darken the lower part of the table to reinforce the overall values and to add an accent with the darkest shading of the drawing.

6

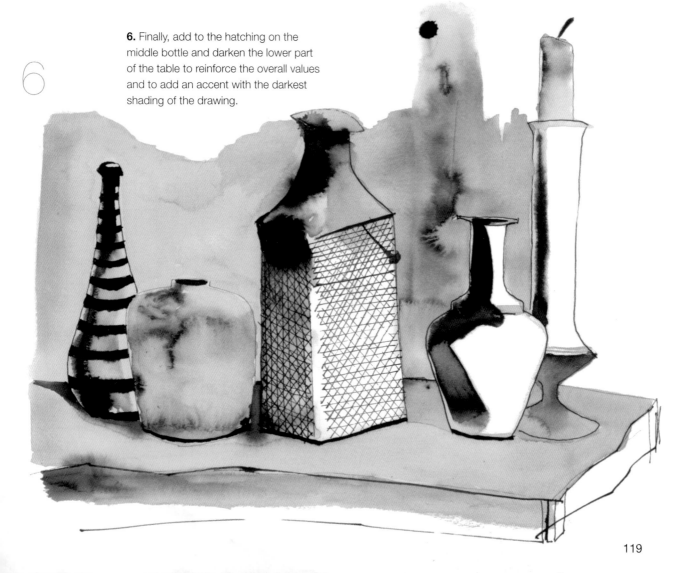

**LEVEL OF DIFFICULTY**
★ ★

**TOOLS**
India Ink
Nib Pen
2B Graphite Pencil

**SUPPORT**
100 lb (250 gr) Smooth Paper

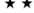

Hatching can be very helpful for creating a wide range of values in a pen and ink drawing. In this drawing, the hatching will make the texture denser and denser until rich deep shadows are created by overlaying numerous lines over each other.

**1.** Draw the subject accurately, and then draw over it with pen and ink.

**2.** Add the first crosshatched lines on the leaves of the tree, crossing them diagonally.

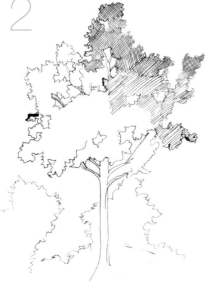

**3.** The density of the hatching should increase in the more darkly shaded parts of the tree. The densest areas are composed of more tightly spaced parallel lines. After finishing the leaves you can begin adding hatching to the trunk and the branches.

**4.** The hatching in the background and at the base of the tree should be lighter, less dense than on the leaves and the trunk. After all the hatching has been added, the exercise is finished.

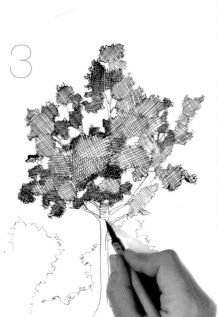

**LEVEL OF DIFFICULTY**

★

**TOOLS**

India Ink

Nib Pen

2B Graphite Pencil

Toothbrush

**SUPPORT**

100 lb (250 gr) Smooth Paper

In the following drawing, we will show you a rather unconventional way of making stippled hatching. This time you will use a toothbrush because you will need to make some marks that are much finer than those you can make with a nib pen. Also, the nature of the subject obviously allows you to use a more informal approach.

**1.** Add some ink lines to the initial drawing made with graphite. As you can see, this will be an informal and very dynamic drawing.

**2.** Wet the toothbrush in a small container of ink diluted with water, and rub it with your finger over the drawing to create stippling in different areas.

**3.** Now work on the lines, creating light hatching with very fine lines on the flowers, and darker lines for the stems.

**4.** The combination of different line widths and hatching, as well as the various stippled areas, will result in a delicate drawing with very rich shading.

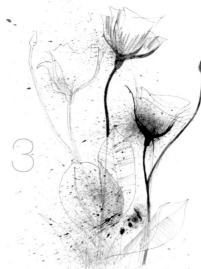

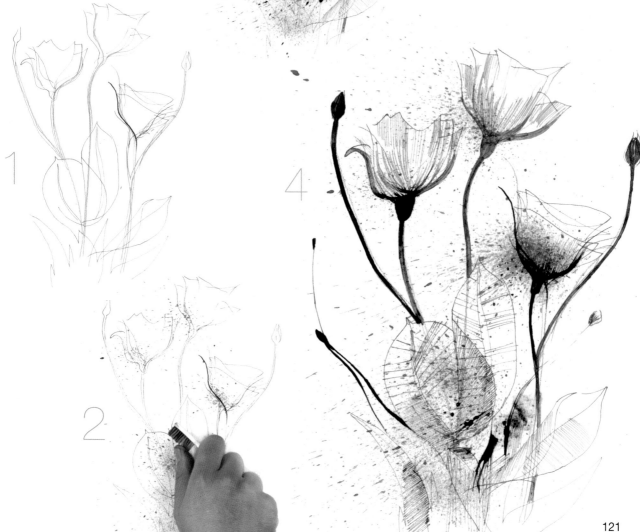

**LEVEL OF DIFFICULTY**
★

**TOOLS**
India Ink
Nib Pen
2B Graphite Pencil

**SUPPORT**
100 lb (250 gr) Smooth Paper

When you wish to make a looser drawing, without falling into the formality of hatching based on parallel lines, an interesting option is to allow the pen line to create free rhythms and accents. That is how you will proceed in this exercise: different kinds of lines and random hatching are combined without a previous plan for this everyday subject.

**1.** Before using the pen, make a very generic pencil drawing. Then go over those lines with ink, in a quick and loose manner.

**3.** The accidental splotch integrates perfectly, caught in the hodgepodge of lines that make up the gears of the bicycle in this graphic work.

**2.** The mechanical details are important because they create a graphic counterpoint to the long stretched out lines.

**4.** Draw this part of the handlebar and add a black handle to create a counterpoint to energize the drawing, which is mainly composed of very fine lines.

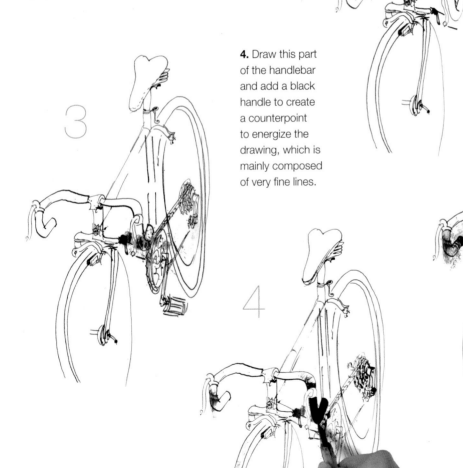

**5.** Repeat the previous trick with more accidental splotches and also apply some hatching in areas that look too bare.

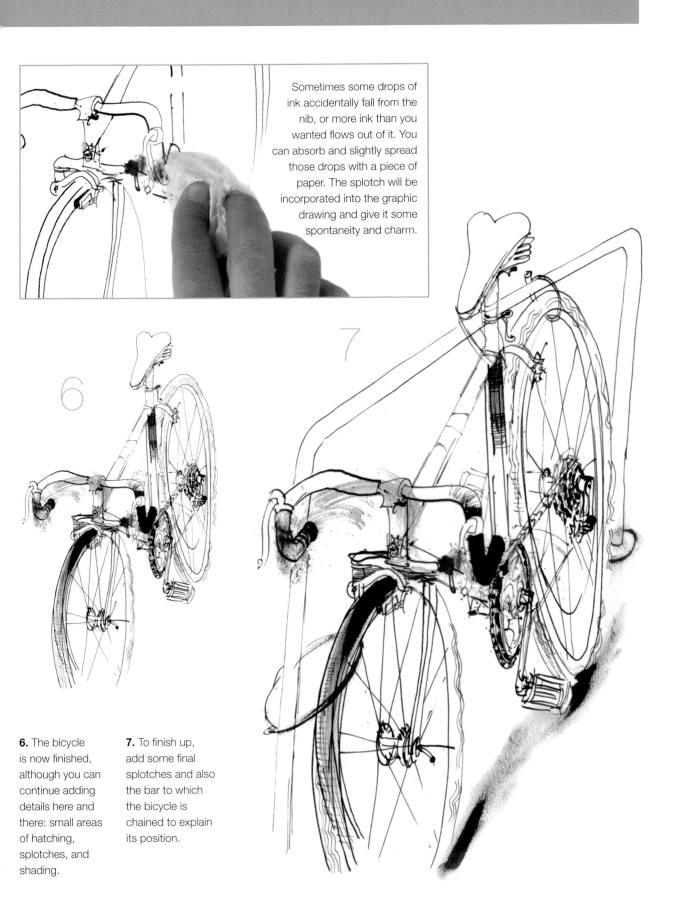

Sometimes some drops of ink accidentally fall from the nib, or more ink than you wanted flows out of it. You can absorb and slightly spread those drops with a piece of paper. The splotch will be incorporated into the graphic drawing and give it some spontaneity and charm.

**6.** The bicycle is now finished, although you can continue adding details here and there: small areas of hatching, splotches, and shading.

**7.** To finish up, add some final splotches and also the bar to which the bicycle is chained to explain its position.

**LEVEL OF DIFFICULTY**

★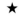

**TOOLS**

India Ink

Nib Pen

2B Graphite Pencil

Round Watercolor Brush

**SUPPORT**

100 lb (250 gr) Smooth White Paper

**This exercise illustrates an important way of creating silky effects based on the natural bleeding of ink in water. The technique cannot be controlled completely and depends on luck to a certain extent, but the results are very interesting, as you will see in this drawing.**

**1.** This is the outline of the silhouette that you are going to draw. First, use a pencil so that you will not hesitate when you are making the ink drawing, which will come at the end of the process.

**2.** Wet the interior of the profile with a brush and clear water, then apply the nib pen with ink on the wet surface to create an area of ink that will spread according to the amount of water contained on the paper.

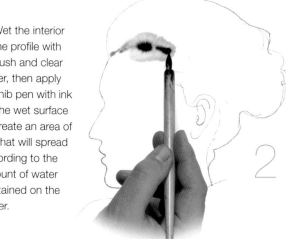

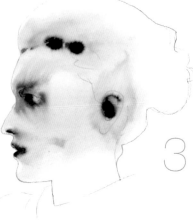

**3.** Spread small splotches of ink around the eye, the mouth, the nose, the temple, and the ear; then draw the shape of each facial feature when the paper is drier.

**4.** Finally, go over the outline, applying pressure to accent the lines of the hair and the nape of the neck, and add some more lines to suggest the movement of the hair.

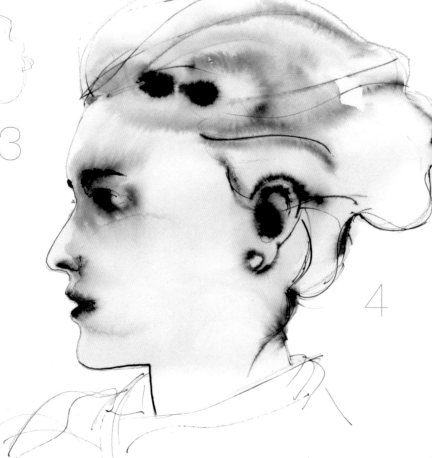

**LEVEL OF DIFFICULTY**
★

**TOOLS**
India Ink
Nib Pen
2B Graphite Pencil
Round Watercolor Brush

**SUPPORT**
140 lb (300 gr) Smooth White Paper

**1.** Start with a simple pencil drawing and then go over the long lines of the tree trunks with pen and ink. Do not add any additional details.

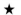

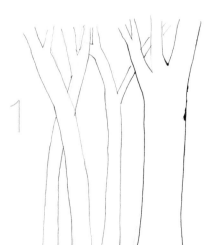

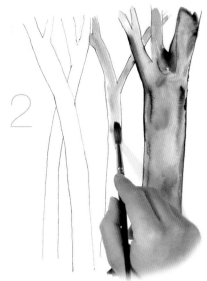

The ink wash is one of the most popular techniques for artists who want to model their drawings with a gradation of many values rich in shadows. This exercise shows a very simple type of drawing that creates many values of ink according to how diluted it is with water.

**2.** Cover the thickest trunk (on the right) with a wash of ink diluted with water to make a medium gray that is not too dark. Use this gray to obtain more tones by diluting it more, just like you can see on the second tree being covered.

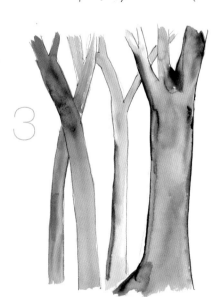

**3.** Cover the rest of the tree trunks with other tones of diluted ink.

**4.** Darken the central tree with less diluted ink to create a darker value than the rest. Then cover the ground with a medium gray.

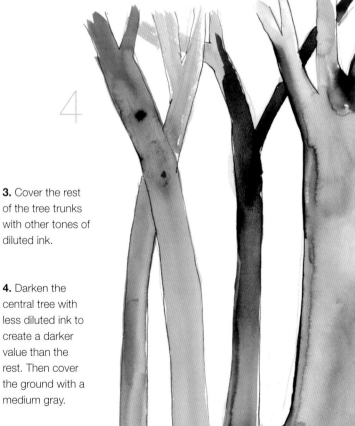

**LEVEL OF DIFFICULTY**
★ ★
**TOOLS**
India Ink
Round Watercolor Brush
**SUPPORT**
140 lb (300 gr) Smooth White Paper

The wash technique is particularly suited to certain landscape themes where the atmosphere, light, and environment are the protagonists in the scene. This landscape clearly demonstrates that ink, all by itself, is a medium with great artistic merit.

**1.** Begin working without an initial drawing. Dilute the ink with water and draw a tree with all its branches from the top to the bottom of the paper.

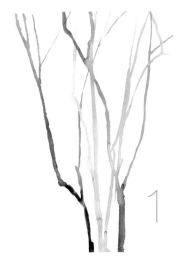

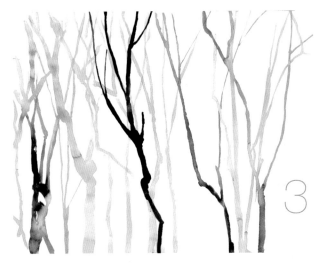

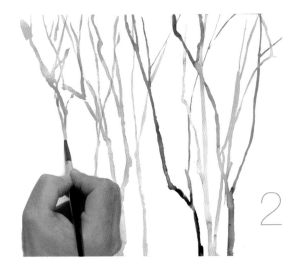

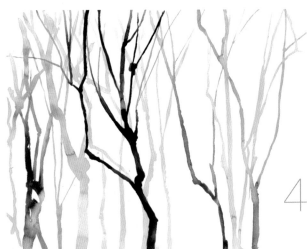

**2.** Here you can see how to draw the branches: hold the brush like a drawing tool and make lines with the point.

**3.** One tree painted with undiluted ink looks like a shape in the foreground because of the contrast, and it is "distanced" from the rest of the forest.

**4.** Continue drawing the branches of the tree in the foreground, adding a little water each time to create slight variations in the intensity.

**5.** Now add some irregular washes that resemble the foliage; use different intensities of ink for this.

**6.** By this point, you have filled in a good amount of foliage with varied tones that create an interestingly detailed effect.

It is best to work with very diluted ink and later, if necessary, to darken the tone rather than the other way around. The very light values can be strengthened, but the darker ones cannot be lightened.

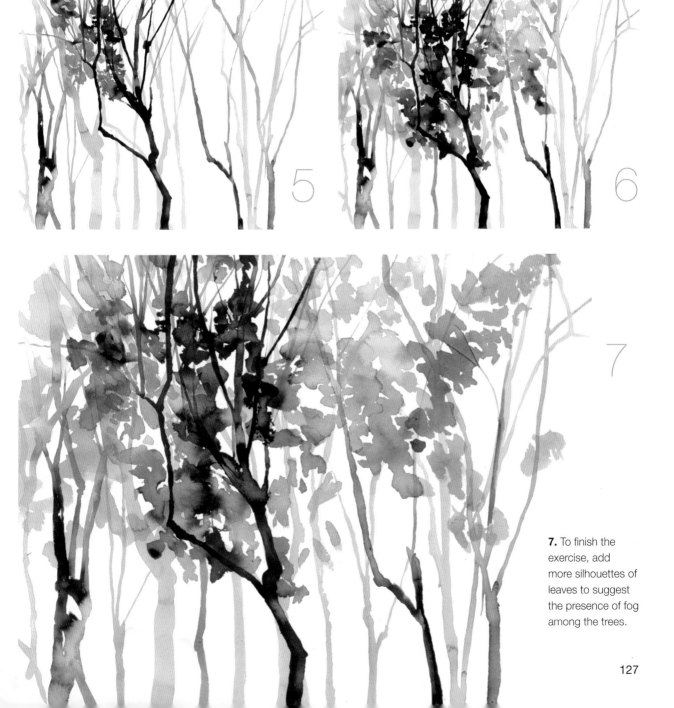

**7.** To finish the exercise, add more silhouettes of leaves to suggest the presence of fog among the trees.

**LEVEL OF DIFFICULTY**
★
**TOOLS**
India Ink
Round Watercolor Brush
2B Graphite Pencil
**SUPPORT**
140 lb (300 gr) Smooth White Paper

The natural tone of India ink is a very deep black. This allows the artist to work with a wide range of tones. Maintaining a clear separation between the different values will allow you to create a very graphic richness, like the lobster represented in this drawing.

**1.** First, make a simplified but clearly detailed drawing of all the parts. Each one will correspond to a black or gray value.

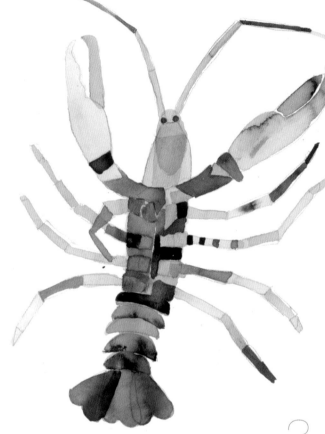

**4.** Finally, retouch some areas that may need a more lively contrast and use some undiluted ink. The result will be graphic and sensitive at the same time.

**2.** Color in the drawing, following the outlines and making sure to create contrasting values between one zone and another.

**3.** The contrasting values give the simple drawing a pleasant look and a sense of three-dimensionality.

**LEVEL OF DIFFICULTY**
★ ★

**TOOLS**
India Ink
Round Watercolor Brush
2B Graphite Pencil

**SUPPORT**
140 lb (300 gr) Smooth White Paper

**Combining pen and ink drawing and ink wash in the same drawing is a very common approach. In the following exercise, we show you how to combine these materials, a technique that requires drawing with diluted ink. The most important thing is that the black lines have their own vitality and that the different shades contrast with each other.**

**1.** Draw the scene in a very loose and simple manner, focusing more on the contrasts between the thicknesses of the lines than on their accuracy.

**2.** Build up the palms with a dense mass of informal hatch lines to create areas with strong graphic qualities.

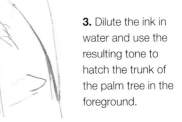

**3.** Dilute the ink in water and use the resulting tone to hatch the trunk of the palm tree in the foreground.

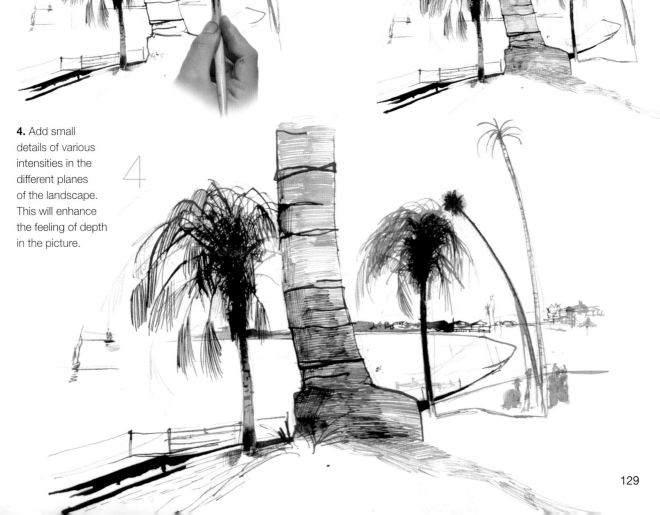

**4.** Add small details of various intensities in the different planes of the landscape. This will enhance the feeling of depth in the picture.

**LEVEL OF DIFFICULTY**
★ ★

**TOOLS**
India Ink
Round Watercolor Brush
Pink and Blue Markers
2B Graphite Pencil

**SUPPORT**
140 lb (300 gr) Smooth White Paper

**India ink and markers are similar media and can be combined without any problems. In this drawing, you will use markers to draw some important small details and resolve the rest of the work with large applications of India ink.**

**1.** The initial pencil drawing should be correct in its proportions and loose in its outlines.

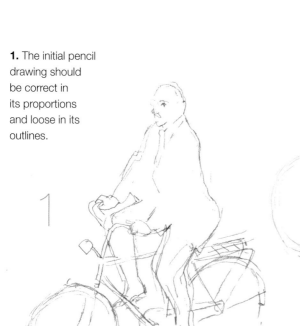

**3.** Using the tip of the brush and some diluted ink, begin drawing some highlights on the frame of the bicycle.

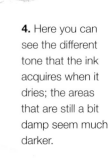

**2.** To start off, add some color to the hands and the face with the pink marker. They should be quick and loose applications.

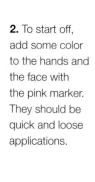

**4.** Here you can see the different tone that the ink acquires when it dries; the areas that are still a bit damp seem much darker.

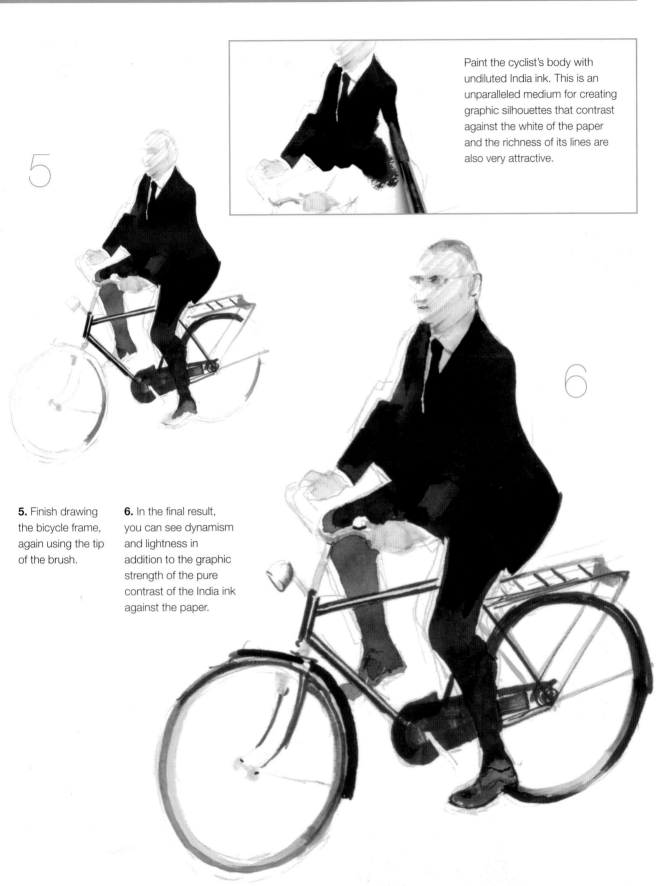

Paint the cyclist's body with undiluted India ink. This is an unparalleled medium for creating graphic silhouettes that contrast against the white of the paper and the richness of its lines are also very attractive.

5

6

**5.** Finish drawing the bicycle frame, again using the tip of the brush.

**6.** In the final result, you can see dynamism and lightness in addition to the graphic strength of the pure contrast of the India ink against the paper.

**LEVEL OF DIFFICULTY**
★
**TOOLS**
India Ink
Round Watercolor Brush
**SUPPORT**
140 lb (300 gr) Smooth White Paper

**1.** Begin by drawing three stalks of bamboo with ink slightly diluted with water. You must increase or decrease the pressure on the tip of the brush to create the shapes of the stalks.

**2.** Now draw some leaves. Press the tip of the brush against the paper to create a wide shape, and reduce the pressure to make a narrow one.

Oriental washes rely solely on brush and ink, with no previous drawing and without using a pen. The traditional approach requires Chinese brushes, but in this exercise you will use the same watercolor brush that you have been using in many of the previous exercises.

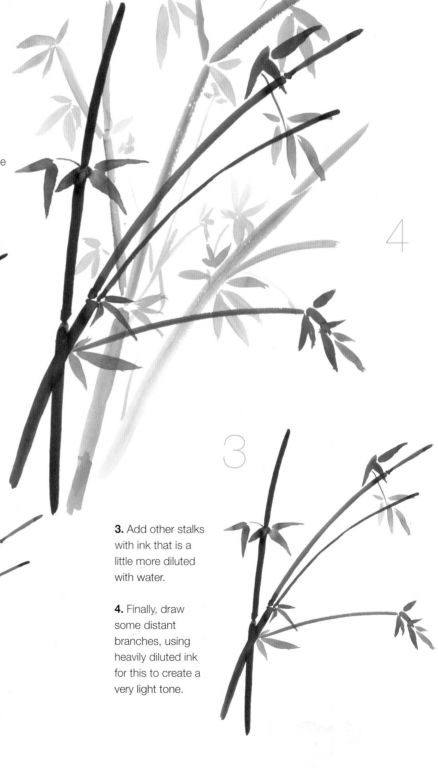

**3.** Add other stalks with ink that is a little more diluted with water.

**4.** Finally, draw some distant branches, using heavily diluted ink for this to create a very light tone.

**LEVEL OF DIFFICULTY**
★

**TOOLS**
India Ink
Round Watercolor Brush
Stick of Natural Charcoal

**SUPPORT**
100 lb (250 gr) Smooth White Paper

The combination of India ink and natural charcoal in the same drawing is not common, although the two media can be combined well enough. Next, you will begin a tentative drawing with charcoal, and after wiping down the entire thing, you will finish it up with India ink applied with a brush.

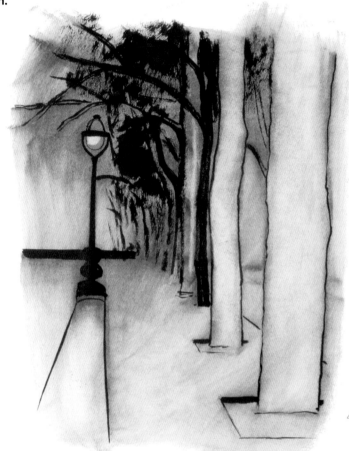

**1.** First draw the subject with natural charcoal, applying enough pressure on the paper so that the marks will be as permanent as possible when they are erased.

**2.** Now erase the drawing with a cotton rag and check to make sure the essential lines of the drawing are still visible.

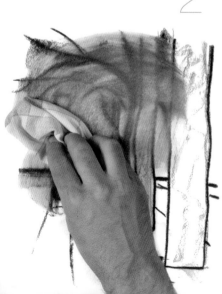

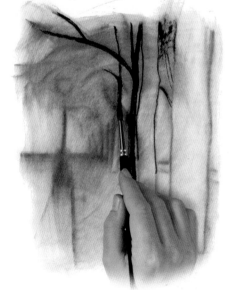

**3.** Go over what remains of the lines with the brush, adding or fixing everything that you want.

**4.** Here is how the drawing ends up: the charcoal works very well in the scene, as a depiction of the atmosphere.

**LEVEL OF DIFFICULTY**

**TOOLS**
India Ink
Red, Blue, Yellow, Orange, Pink,
Green, and Sepia Color Inks
Nib Pen
2B Graphite Pencil
**SUPPORT**
100 lb (250 gr) Smooth White Paper

Color inks, which are sometimes improperly referred to as liquid watercolors, are sold in a limited range of colors whose most useful tones are those you will use here. They are not permanent colors, as they do not stand up to prolonged exposure to light, but they are very vibrant and can easily be adapted to any kind of illustration work.

**1.** This is a simple pencil drawing that you will lightly erase before beginning to draw with the nib pen and inks.

**2.** First use the yellow to draw all the lines that indicate the roofs and the upper floor.

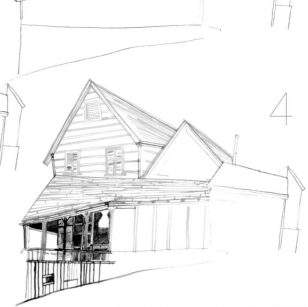

**3.** Use red to outline the shingles and blue for the gutters. The criteria for choosing the colors are up to the imagination of the artist.

**4.** The color sepia adds a more somber tone that will work well on the lower areas of the drawing. It is here that you can build up many details thanks to the number of objects that can be seen under the porch.

It is most logical to use the darkest inks at the end of the process so the pen will not stain the lighter colors. But you should also be aware that, before each color change, you should rinse the pen with clean water.

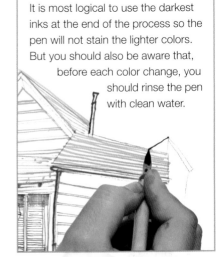

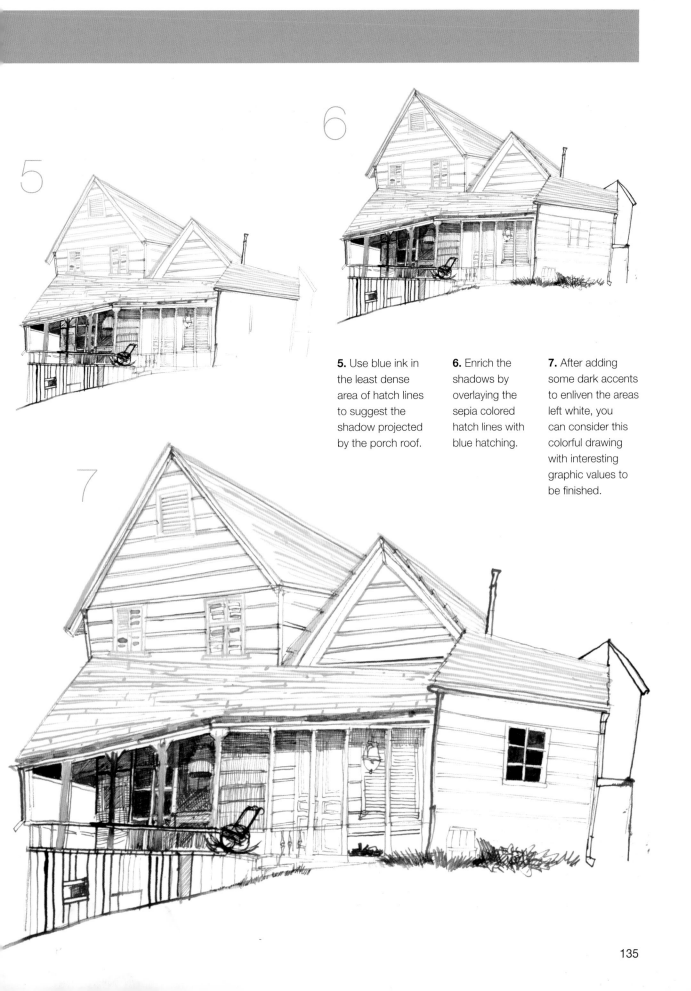

**5.** Use blue ink in the least dense area of hatch lines to suggest the shadow projected by the porch roof.

**6.** Enrich the shadows by overlaying the sepia colored hatch lines with blue hatching.

**7.** After adding some dark accents to enliven the areas left white, you can consider this colorful drawing with interesting graphic values to be finished.

**LEVEL OF DIFFICULTY**
★

**TOOLS**
India Ink
Nib Pen
Round Watercolor Brush

**SUPPORT**
100 lb (250 gr) Smooth White Paper

**A brush can actually be a drawing tool when it is used with India ink. The thickness of the brushstroke or line can vary greatly, and it will allow you to work with a lot of flexibility once you have acquired enough practice to control the amount of ink in the brush and the amount of pressure you put on it.**

**1.** The initial drawing can be made directly with the nib pen, making long lines that indicate the deep space of the composition.

**2.** These stepped strokes will suffice to represent the treetops. Make them by drawing parallel lines with the brush just like you see here in the smallest strokes, allowing them to be slightly separated from one another.

**3.** Use the pen to extend the heavy brushed lines with finer lines in some areas that require extra hatching.

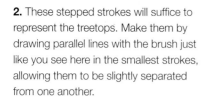

**4.** This technique uses ink and a brush to imitate quick pencil lines. Some artists often use this technique for the sketches and quick drawings they make on site.

**LEVEL OF DIFFICULTY**
★

**TOOLS**
Red, Blue, and Yellow Ink
Round Watercolor Brush
2B Graphite Pencil

**SUPPORT**
140 lb (300 gr) Smooth White Paper

If you are working with a brush, drawings made with color inks are nearly indistinguishable from watercolor paintings; in both cases, you are spreading strokes of color on the paper. You can also use the dry brush technique in both media, which consists of continuing to draw with the brush after almost all of the ink has been spread on the paper.

**1.** Color the area that will be the face of the figure with yellow. Do not follow a specific pattern, but make sure that the brushstrokes are all visible.

**2.** Outline the figure's hair using red ink and the tip of the brush.

**3.** Now that the brush is nearly out of ink, rub the area of the hair to create the "dry brush" effect, that is, lines that are irregular and not very fluid.

**4.** Add the details of the features to the face with the tip of the brush. The irregular lines add a textural effect to both the red and blue brushstrokes.

**LEVEL OF DIFFICULTY**
★ ★
**TOOLS**
India Ink
Red, Blue, Yellow, and Green Color Inks
Nib Pen
**SUPPORT**
140 lb (300 gr) Smooth White Paper

Color inks can create splendid results when they are used in a loose manner, as we demonstrate in this exercise. You will work without mixing the colors and without diluting them with water: directly, and even applying the inks in unconventional ways.

**1.** Begin scribbling without any previous sketch or drawing, using yellow exactly as explained in the following image.

**2.** Apply the yellow and then the green with the dropper incorporated in the lids of the ink bottles. This is a very imprecise way of working, but it is also exactly what you are looking for here, unexpected effects.

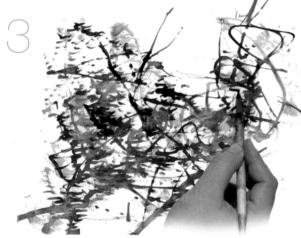

**3.** Use the nib pen to spread the previous strokes in a horizontal direction to create an effect like that of dense foliage. You can also use it to apply the red lines.

**4.** Add blue strokes on the lower part of the drawing to represent the surface of a river. Also spread some of these lines on the rest of the drawing to enrich and unify the work.

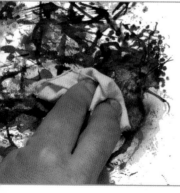

The ink that puddles on the paper can be absorbed with a cotton rag or a piece of absorbent paper, which will create a somewhat diluted tone that will enrich the work. This technique can be carried out in the final phase of the process, when the paper has already absorbed enough ink.

**5.** Now apply dots to suggest leaves, stems, and other small details that will make the representation more convincing.

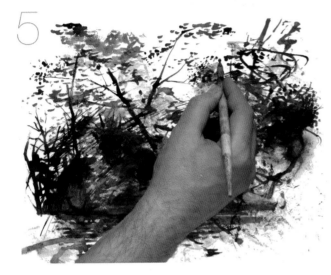

**6.** The attractiveness of this loose and casual technique rests in the apparent chaos of the scene, from which emerges an interesting representation of the dense part of a forest or jungle.

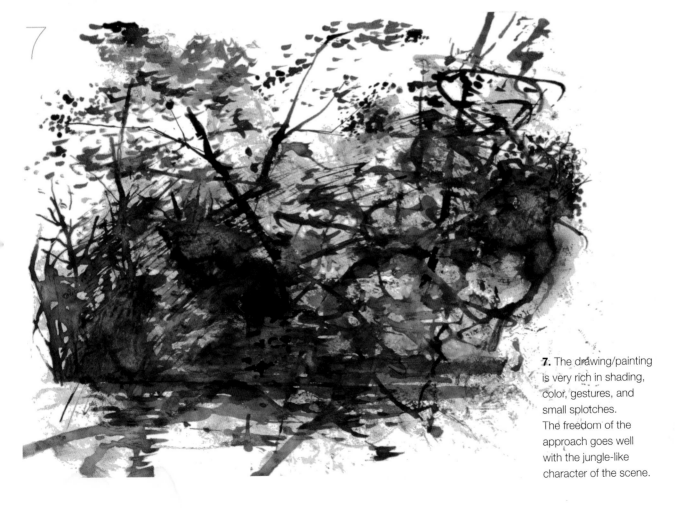

**7.** The drawing/painting is very rich in shading, color, gestures, and small splotches. The freedom of the approach goes well with the jungle-like character of the scene.

**LEVEL OF DIFFICULTY**

★

**TOOLS**

Pink, Red, Green, and Gray Markers
2B Graphite Pencil

**SUPPORT**

100 lb (250 gr) Smooth White Paper

In this exercise, you will use the markers to highlight a drawing, rather than coloring it. Three markers should have thick tips (pink, gray, and green), and one a fine point (red). The pink one should be quite used and make weak strokes, which will make it very helpful for your purposes.

**1.** First, make a pencil drawing of the entire outline of the pig using one continuous line.

**2.** Apply pink on the more shaded areas of the body, pressing quite hard on the paper with the tip of the marker.

**3.** Cover the ground with thick strokes of the green marker. Then lightly color the pig's body with pink, creating a very faint tone with very visible strokes.

**4.** Cover the background of the drawing with gray strokes, and then immediately use the fine-point marker to finish drawing the last details.

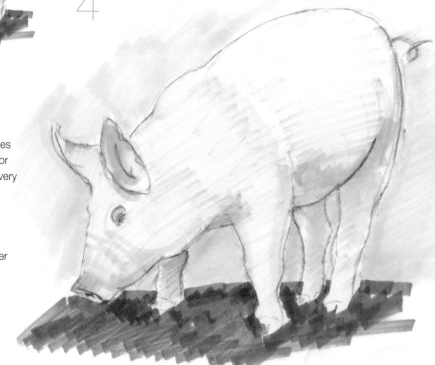

**LEVEL OF DIFFICULTY**

★ ★

**TOOLS**

Red and Yellow Markers

2B Graphite Pencil

**SUPPORT**

100 lb (250 gr) Smooth White Paper

**Lines made with markers have strong colors, and the fine-point markers can be very precise. The following exercise consists of a simple drawing of an urban scene that demonstrates the strength of this medium in a very simple and almost sketchy approach.**

**1.** Draw a few guidelines with a pencil; then begin drawing with the yellow marker. Indicate the curve of the street and the distribution of each one of the façades.

**2.** Use the red marker to draw the upper parts of some of the façades, drawing several overlaid lines, and then begin drawing the details of the doors and windows.

**3.** Include details in the windows to enliven the drawing and also to create contrasts in sizes that will help create a feeling of depth.

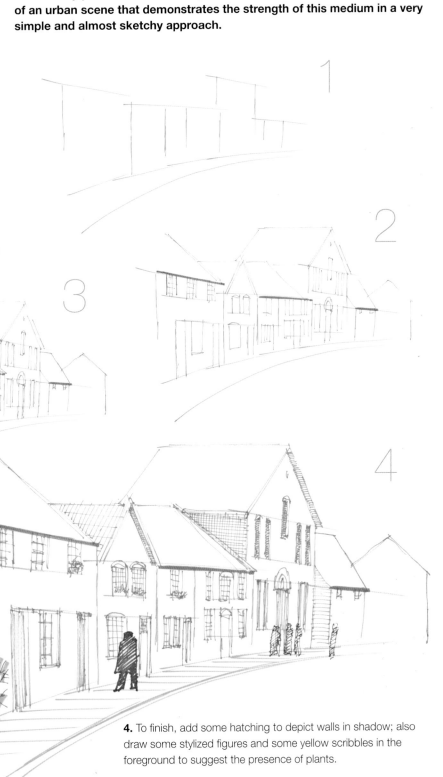

**4.** To finish, add some hatching to depict walls in shadow; also draw some stylized figures and some yellow scribbles in the foreground to suggest the presence of plants.

**LEVEL OF DIFFICULTY**

★

**TOOLS**

India Ink

Yellow, Blue, Green, and Red Color Inks

Yellow, Blue, Green, and Red Markers

Nib Pen

Round Watercolor Brush

2B Graphite Pencil

**SUPPORT**

140 lb (300 gr) Smooth White Paper

**In this last exercise, you will attempt a very simple subject, a free form that is indebted to the Cubist style of the mid 20th century. It is an ornamental work that is full of contrasting lines, hatching, and colors.**

**1.** Begin with a drawing of the subject based on exaggerated and very ornamental shapes done in pencil.

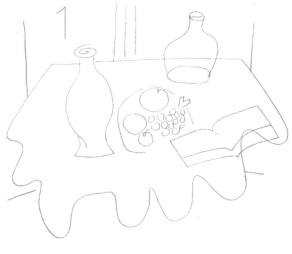

**2.** Stipple the tablecloth with a pen and yellow ink. The direction of the stippling can change in different parts of the tablecloth to keep it from looking too mechanical.

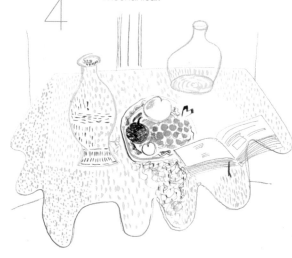

**3.** Now work with blue ink diluted with water and applied with the pen, making different hatch marks like dots, lines, and scribbles, on different parts of the center of the tablecloth.

**4.** Draw and color the fruit that is inside the fruit bowl with yellow and green ink, using more saturated and undiluted tones.

Use the brush to spread the color of the background: apply blue and red tones in different dilutions. The resulting tones will range from gray (very diluted blue) to some oranges made by mixing the red with a little bit of yellow.